30-SECOND
PHOTOGRAPHY

THE 50 MOST THOUGHT-PROVOKING PHOTOGRAPHERS,
STYLES & TECHNIQUES, EACH EXPLAINED IN HALF A MINUTE

Editor
Brian Dilg

Contributors
Brian Dilg
Adiva Koenigsberg
Jackie Neale
Marc Prüst
Ben Sloat

IVY PRESS

This edition published in the UK in 2017 by
Ivy Press
An imprint of The Quarto Group
The Old Brewery, 6 Blundell Street
London N7 9BH, United Kingdom
T (0)20 7700 6700 **F** (0)20 7700 8066
www.QuartoKnows.com

British Library Cataloguing-in-
Publication Data
A catalogue record for this book is
available from the British Library

ISBN: 978-1-78240-517-7

This book was conceived,
designed and produced by
Ilex Press

Publisher **Alastair Campbell**
Executive Publisher **Roly Allen**
Associate Publisher **Adam Juniper**
Art Director **Julie Weir**
Editorial Director **Nick Jones**
Senior Specialist Editor **Frank Gallaugher**
Senior Editor **Natalia Price-Cabrera**
Assistant Editor **Rachel Silverlight**
Designer **Ginny Zeal**
In-House Designer **Kate Haynes**
Illustrator **Ivan Hissey**
Picture Researcher **Katie Greenwood**

Printed in China

10 9 8 7 6 5 4 3 2 1

CONTENTS

INTRODUCTION
Brian Dilg

It is estimated that we as a species will generate
over a trillion photographs in 2017 (compare this to the estimated 3.8 trillion
images made in the entire history of photography!). Since billions of people
are now at least amateur practitioners of a medium that has become as
accessible as mobile phones, we might presume to believe that we all more
or less understand what photography is. Hasn't digital technology made
photography easy? Isn't the content of a photo obvious?

Well, no and no. Philip-Lorca diCorcia's comment has never been more
true: 'Photography is a foreign language everyone thinks he speaks'. What
looks like a simple two-dimensional representation of reality contains not
just its subject, but also its time and place, its maker, the implication of what
was left outside of the frame; what happened before this moment and what
might happen next; and most fascinating of all, the viewers themselves,
mirrored by their very individuated interpretations, filtered through their own
cultural and historical background. And cameras, despite the false assurance
of a little TV screen on the back, know just as much now about how to take
a good picture as they ever did, which is to say: absolutely nothing.

It is not terribly difficult to make a pretty picture, especially with today's
technically sophisticated cameras. Try typing 'sunset' into your internet
search engine to see how many billions have tried. While the appetite for
being wowed by pretty images seems inexhaustible, over a longer period,
it proves to be a candyfloss diet: sweet, but not very filling.

If you visit any major museum in the world, you will find massive
history paintings commemorating important battles, expertly executed
in painstaking life-and-death detail. You will have plenty of room to stand
in front of these paintings and examine them at your leisure, because the
crowds are elsewhere. One place you are guaranteed to find them is in front
of a simple portrait of a long-forgotten woman with her hands in her lap, a
somewhat fanciful landscape behind her. Why has da Vinci's portrait of the
Mona Lisa endured as one of the most iconic images in history? There is no
high drama, no life and death; she is not the most historically significant or

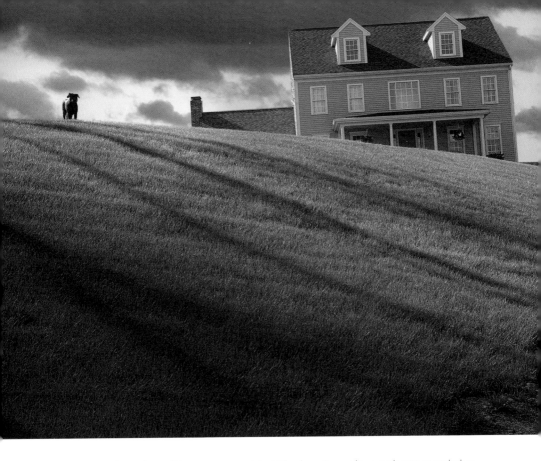

Not all images are what they appear to be, and precisely that openness to interpretation is what is so enticing about many successful photographs.

beautiful woman ever painted. She doesn't even have eyebrows or eyelashes. (The theory is that cleaning wore them off years ago.) It's impossible to tell what she is feeling, or whether she is even smiling or not. What is it about this ambiguity that has fascinated so many viewers? Her smile holds a clue: by making it impossible for us to definitively read her expression, da Vinci has invited countless generations of viewers to discover for themselves the most powerful tool available to any photographer: the imagination of the viewer. Photographers who can never get enough of the latest start-of-the-art, mega-resolution, hyper-sharp camera equipment might consider why leaving something to the imagination might be more satisfying to their viewers than rendering every blade of grass in excruciating, super-saturated detail (and save them a few pounds).

In 1967, curator John Szarkowski presented the work of three still-obscure photographers, Diane Arbus, Lee Friedlander and Garry Winogrand in a show at New York's Museum of Modern Art. These were not the formal, immaculately composed images of Ansel Adams or Edward Weston, nor the seductive surfaces of their predecessor, Edward Steichen. They were askew, almost random, and they looked directly at the very subjects that most of us do not see because we overlook them as not worth our attention. Szarkowski described it thus: 'Their aim has been not to reform life, but to know it'. Photography presents us with an opportunity to slow down and get to know that which we most take for granted. It may even include our own families and neighbours. Szarkowski said the best pictures were of ordinary things, but perhaps Dorothea Lange put it best: 'A camera is an instrument that teaches people how to see without a camera'.

The seven chapters of this book touch on a comprehensive range of aesthetic, technical, theoretical and historical aspects of the medium. **Visual Language** introduces the reader to the grammar of photography, beginning with the act of containing the world within a frame – which is also to choose what to omit. **Historical Movements** surveys some of the major subject areas and styles, the complex intersection of content, form and idea. **Capturing the Image** is a crash course in the technical tools used to turn light into a latent image. **Composition** covers the tools every image-maker employs to create photographic form – the how of an image, which has a profound effect on how we understand what is being shown. **Light & Lighting** breaks down the literal material of the photographic image, light itself, into its constituent parts and ways in which it can be shaped to create mood and visual style. **Photographic Theory** is as much about us as viewers as it is about how the context in which images are made and received affects our interpretation of them. Finally, **Image Processing & Reproduction** takes a close look at just how much of photography happens after the shutter is released.

Like your favourite supermarket filled with delights, there is no need to worry about the order in which you digest these gems. But following a thread of related ideas might lead you to discover some especially tasty pairings. Most of all, we hope that your awareness of the subtlety and richness hiding in this most democratic of mediums grows across these pages, and that you're inspired to look at the world around you with deeper appreciation, whether or not you have a camera in your hands.

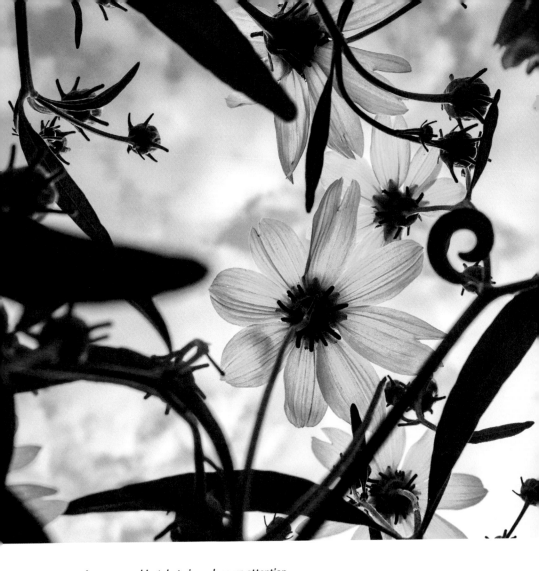

A common subject, but given close-up attention and presented from an unusual angle. Varying even one element – vantage point – opens up limitless possibilities.

VISUAL LANGUAGE

aperture The opening of the lens through which the light enters the camera. A large opening allows for a large amount of light, and will give the resulting image a small depth of field. Aperture is measured in f-stops. A low number indicates a large lens opening, and a high number a small opening.

caption Text that accompanies a photograph and explains the elements of the photograph and the context in which the photograph was taken.

depth of field Often abbreviated as DOF, it's the area of the image that is in acceptable focus. Large DOF or 'deep' focus (achieved by a small aperture) is when most or all elements within the photograph are in focus. A picture in which only one element at one particular distance is in focus has a shallow DOF.

form The suggestion of a three-dimensional form, as opposed to a two-dimensional shape, helps to give a photograph a spatial element. Strong lighting and heavy shadows can help give the form a sculptural feel.

ISO The standard of how the light sensitivity of photographic film or a digital sensor is measured. The lower the number, the lower its sensitivity, so that ISO 50 film needs more light to be correctly exposed than an ISO 1600 film.

interpretation Interpretation by the viewer is an important element in the reading and understanding of a picture, as a photograph is not able to communicate as clearly and directly as most text, for example. Interpretation is important to determine what the photographer wanted to express with the picture.

monochrome Literally an image rendered in shades of any single colour, but in photography, this commonly refers to greyscale imagery. Digital monochrome images typically contain 256 or 65,536 shades of grey (8 or 16 bits).

motion blur An artefact whereby either the subject or the camera moves while the shutter is open, moving the image of the subject across the sensor or film and recording a translucent, streaking image of the subject's path mixed with what was behind it. This is sometimes done deliberately as a creative choice or to convey a sense of movement, or eliminated or reduced deliberately through the use of shorter shutter speeds, shorter focal lengths or by panning the camera to follow the movement of the subject.

presentation Where the photographer is in control of how and where his or her work is seen. It concerns the place (magazine, gallery, Facebook etc.) and also the size and material of the print and the frame.

scale The relative size of the objects represented in the photograph, depending on how they are photographed. As the actual size of an object is not visible in a photograph, the scale can be used to either show or not show the actual size of an object.

shutter speed The speed at which the shutter opens and closes, often described in milliseconds. The longer the speed, the more light can enter the camera onto the film or the light-sensitive sensor that captures the image. A longer shutter speed can also create so-called motion blur, as the object moves during the time the shutter was opened.

snapshot aesthetic A style that uses the transitory method of the snapshot to create a sense of informality. One well-known photographer who uses this aesthetic is Nan Goldin, who documents her social world with a small-format camera. Her photos, due to their deep sense of intimacy and casualness, create a powerful emotional resonance. With the rise of social media, the snapshot aesthetic has become among the most familiar kinds of images on the internet.

still life A work of art with inanimate objects as the central subject. A familiar kind of painting since the Greek and Egyptian eras, still lifes are often portrayed on a tabletop and often demonstrate a physical and metaphoric tension between the objects depicted. Though still, the impression of motion and compositional dynamism are key aspects. Dramatic light is also a common component in still-life scenes, especially in a photographic context.

subtext The subtext of the photograph is that which is suggested but not explicitly shown in the picture.

FRAME

the 30-second focus

To photograph is to select.

When you take a picture, you frame a tiny piece of reality inside your viewfinder or smartphone screen, excluding everything that is outside the area that the lens captures. When you look at a photograph, you can see only what is inside the frame, of course. The first thing you see is what is placed in the middle. People with a Western background read a photograph like a text: from the top left to the bottom right. An easy-to-read frame follows this logic. All the action happens within the frame, and does not trigger the viewer to imagine a larger reality. The edges of the frame do not contain critical information about the subject or the action, and are often a little darker than the centre of the frame, as this keeps the viewer's eye locked inside the photograph. Sometimes, however, the framing can suggest a larger reality: as if there is an opening toward the world outside the frame, and the viewer is tempted to imagine the world outside the frame. This allusion to a larger reality is a powerful tool of a photographer, as it can keep the viewer's attention with the frame, while not within the frame.

RELATED TOPICS
See also
HUMAN PERCEPTUAL SYSTEM
page 118

3-SECOND BIOGRAPHIES
IRVING PENN
1917–2009
Fashion photographer known for his elegant compositions that often employed the square format of medium-format cameras

30-SECOND TEXT
Marc Prüst

3-SECOND FLASH
The edges of the photograph form the frame and this defines what we both see within, and imagine is outside the picture.

3-MINUTE EXPOSURE
Photographers who consciously suggest a larger reality that continues outside the formal frame of their picture can be said to use the subjective grammar of photography. The viewer's imagination is called upon to help create the subjective interpretation of reality. When, on the other hand, all the action does indeed happen within the frame, the picture can be said to aim to present a more-or-less objective representation of reality. The picture then uses objective grammar.

Brian Dilg, *Stay*

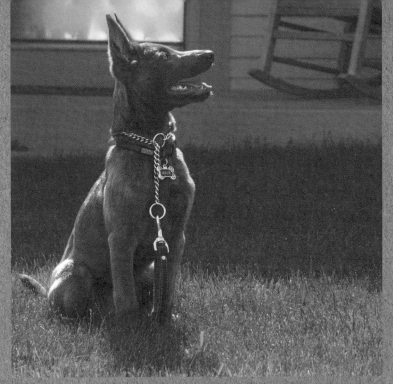

*The frame contributes
to the meaning of the
photograph – and is
capable of changing
the meaning entirely.*

PROXIMITY

the 30-second focus

What is the difference between

a writer and a photographer? A writer can write words based on what he or she hears from others; a photographer has to be there in order to take the pictures. And because the photographer is there, the viewer is there, too. When you look at a picture, you are at the same place as the photographer – you are transported back in time when you look at a historical picture; you are in a war zone when you look at conflict photography. In traditional photo documentary, many lived by Robert Capa's maxim: If your picture isn't good enough, you weren't close enough. According to this famous photographer of the Spanish Civil War and World War II, and co-founder of Magnum, conflict photography was all about being there where the action happened. Being close to something creates intimacy, the illusion of being present, but it also creates a sensation of voyeurism, especially when looking at pictures of intimate or embarrassing situations, like domestic violence, or paparazzi pictures taken with long telephoto lenses. Still, it is this proximity, that we see something we haven't seen before, that makes these pictures, like war zones or historical sites, exciting to look at.

3-SECOND FLASH
The distance between the photographer and the scene he or she is depicting that creates the intimacy and interest of a picture with the viewer.

3-MINUTE EXPOSURE
Yale professor and photographer Tod Papageorge appropriated Capa's maxim: If your picture isn't good enough, you haven't read enough. It is not so much the physical distance between camera and subject but the photographer's understanding of a subject that determines a photograph's success. It is easier to make a touching portrait of your own partner than of someone you have never met: The proximity between photographer and subject is literally or figuratively an important factor when taking pictures.

RELATED TOPICS
See also
DOCUMENTARY
& PHOTOJOURNALISM
page 38

3-SECOND BIOGRAPHIES
ROBERT CAPA
1913–54
American war photographer of Hungarian descent; co-founder of Magnum

TOD PAPAGEORGE
1940–
American street photographer and director of Yale undergraduate photography programme (1979–2012)

30-SECOND TEXT
Marc Prüst

Robert Capa, *Loyalist Militiaman at the Moment of Death, Spain, Cordoba front, September 1936*

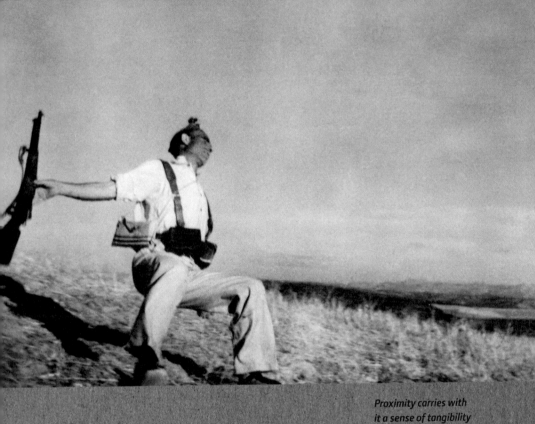

Proximity carries with it a sense of tangibility and, in the right context, explicit danger.

TIME

the 30-second focus

Some of the most prized photos

of all time often utilize perfect timing as a tool to create narrative. Using timing as a visual language means consciously choosing just the right moment to trigger the shutter. A sense of timing is telling about how the photographer sees the moment. Henri Cartier-Bresson, a twentieth-century photographer, demonstrated perfect timing in a photograph of a man leaping off the edge of a ladder into a seemingly large reflective puddle, subtly echoing the poster behind him. With his foot just dangling above the puddle, the viewer is left to imagine what happened next. The tension created by the timing of the capture visually communicates a larger story. Candid photography is essentially defined by well-timed captures. Spontaneous photography became quite popular after the introduction of smaller, handheld cameras, like 35mm SLRs. On the other hand, some photographers choose to take photographs devoid of any timing clues, as in the vein of Bernd and Hilla Becher's photographs, where images appear stagnant and stuck in time – images that give no sense of a year or date. Becher-esque photography serves as a clear contradiction to the 'decisive moment' visual language, existing without any moving parts to capture 'in time'.

3-SECOND FLASH
Time can be used as a narrative tool, to establish a mood or sentiment, or to communicate an invisible interaction between the photographer and their environment.

3-MINUTE EXPOSURE
A large majority of photography is reliant on timing. Judging when a gesture will be made, when the sun will reach its perfect angle, or when the train will cross the horizon are all essential elements for a photographer. Timing peculiarities of shooting a photograph at just the right moment are all important to the conveyance of the photographer's message. Perfect timing is the photographer's profession.

RELATED TOPICS
See also
EMERGENCE
page 84

SURPRISE
page 120

3-SECOND BIOGRAPHIES
HENRI CARTIER-BRESSON
1908–2004
A twentieth-century French photographer known for photojournalistic, 35mm photography, and for coining the term 'The decisive moment'

30-SECOND TEXT
Jackie Neale

Henri Cartier-Bresson, *Place de l'Europe, Gare Saint-Lazare, France, Paris, 1932*

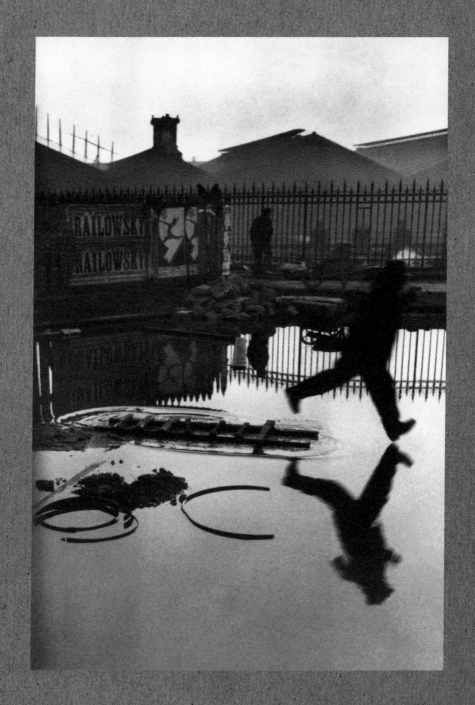

REPRESENTATION

the 30-second focus

3-SECOND FLASH
What is described in a photograph in terms of subject matter, often seeming objective, but easily made subjective by a photographer's intentions.

3-MINUTE EXPOSURE
Major changes in photographic technology have deeply affected representation. Initial limitations such as the need for long exposures created kinds of visual representation not able to be seen by the human eye. High-speed exposures, beginning with the work of Eadweard Muybridge, created photographic representations faster than the eye could see. In present day, digital cameras and the use of the computer for post-production also create massive shifts in photographic representation.

What is seen in the photograph,

in terms of subject and content, and how it is shown, can be termed 'representation'. The literal subject matter in a photograph, what is present in front of the camera, is often known as the index. The photograph can show a variety of subjects, creating the impression of truth, but the photograph can also describe the situation that the photographer was in when the picture was made. In a sense, representation itself can tell many kinds of stories, as well as demonstrate multiple perspectives. The complexity here is that while the photograph can appear to be an objective representation, it can easily become subjective based on the photographer's ability with the camera to edit, crop, infer or objectify. Similarly, many post-production methods (whether digital or analogue) can alter a photograph's representation. As viewers have become increasingly sophisticated in reading photographic intent, issues of the photograph's ability to directly represent in an objective manner have often been called into question. Where a picture was once 'worth a thousand words', now one may think of Lewis Hine's quote: 'Photographs don't lie, but liars photograph'.

RELATED TOPICS
See also
ATTENTION
page 122

CONTEXT
page 124

FIGURE/GROUND
page 76

FOCUS
page 22

DENOTATION & CONNOTATION
page 114

3-SECOND BIOGRAPHIES
LEWIS HINE
1874–1940
American sociologist and photographer who used his art for social advocacy

EADWEARD MUYBRIDGE
1830–1904
English pioneer of high-speed photography

30-SECOND TEXT
Ben Sloat

Louis-Jacques-Mandé Daguerre,
Boulevard du Temple, Paris, 1838

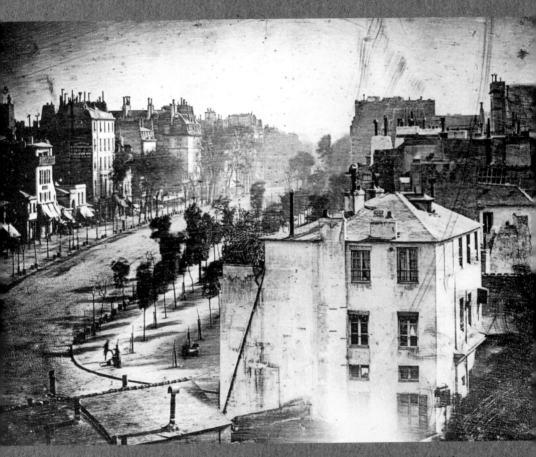

This may well be the very first photograph (in fact, a Daguerreotype) that managed to capture a living person. During the several-minutes-long exposure, most of the movement in this busy street in the middle of Paris was blurred into oblivion – except for the man who stood still long enough to get his shoe shined at the corner of the street in the lower left of the frame.

FOCUS

the 30-second focus

Since the introduction of

autofocus as a standard feature in consumer cameras, it is no longer a technical difficulty to get the main subject in the middle of the frame sharp and neat, even if the object is moving with great speed, or when many other elements are placed at different distances from the camera. The introduction of autofocus also meant that many photographers mindlessly started to put the subject of their picture exactly in the middle of the frame, because that was where the autofocus worked best. The element within the frame that is sharp attracts our attention. It is where the viewer's focus goes, immediately. Other photographers use blur, consciously taking the technical sharpness out of their pictures in order to create a certain atmosphere. Indeed, motion blur can very effectively suggest speed; a very sharp object within a blurred surrounding can suggest a sense of space, and render the flat photographic surface with a 3D quality. But blurry images can also create a nightly, ghostly or even scary atmosphere. The elements in the frame become hard to recognize, and force the viewer to fill in the gaps, to use their imagination.

3-SECOND FLASH
The technical sharpness in a photographic image, often used to direct the viewer's attention.

3-MINUTE EXPOSURE
Blurred images can be very attractive. However, there is a payoff. The human brain creates an image from what the eyes perceive. The brain, unlike the light-sensitive component of a camera, puts the entire image into focus. Humans perceive the world in perfect sharpness. If we don't, we buy ourselves a pair of prescription glasses. Images that have a large area that is out of focus can be very exhausting to look at – the brain keeps trying to get the image in focus, but what isn't in focus in the first place will never appear sharp.

RELATED TOPICS
See also
HUMAN PERCEPTUAL SYSTEM
page 118

FRAME
page 14

3-SECOND BIOGRAPHIES
GROUP F/64
1932–35
A group of photographers in California that exhibited a new style in which the subject was always in sharp focus, in refutation of the soft-focus pictorialist style that was the presiding fashion at the time

30-SECOND TEXT
Marc Prüst

Brian Dilg, *Men in Suits, New York City, 2012*

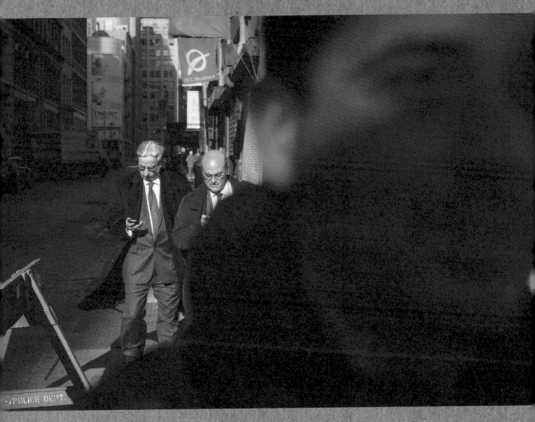

Even a large, completely out-of-focus foreground object can contribute substantially to the meaning of an image.

LIGHT

the 30-second focus

Light is to a photographer, like

water is to a fish. Photographers are known as light stalkers, searching for beautiful light sources. Light must strike the surface of the sensor or film in order for an image to be captured. The amount of light that hits the light-sensitive surface is controlled by the camera's exposure settings: a combination of ISO, shutter speed and aperture; but that doesn't begin to describe its effect on us. Light can come in the form of sunlight, moonlight, candlelight, lamps, lightning, fireflies and flash, but without so much as a little bit of light of some kind, a photograph cannot be taken. There are harsh sources of light, like a spotlight, and there are soft sources of light like billowy clouds on an overcast day. There are cold colour-temperature light sources like winter morning skylight, and warm light sources like a tungsten lamp's incandescent bulb. Taking into account the colour temperature of a light source is imperative, and needs to be acknowledged in the camera's white-balance settings. The way a photograph is lit is essential to a successful image. Small amounts of light can create drama; large amounts of light can quite literally reveal what would otherwise have remained unseen.

3-SECOND FLASH
Film or a digital sensor is latent (blank) until light is exposed to it, creating an image. Every photograph needs light to exist, hence the term, 'latent image'.

3-MINUTE EXPOSURE
Photographers continuously evaluate light for its dramatic, narrative and poetic qualities, either waiting for the right light, or creating it themselves. Using available light like the sun requires working around its intensity throughout the day as well as changing weather. Working with studio lighting, the photographer sculpts light to match their vision of the finished photograph.

RELATED TOPICS
See also
EXPOSURE
page 58

STROBE LIGHTING
page 62

THREE-POINT LIGHTING
page 96

3-SECOND BIOGRAPHIES
MAN RAY
1890–1976
The inventor of the Rayograph, born Emmanuel Radnitsky, he was an American photographer living in Paris who explored modernist techniques with light and photography

30-SECOND TEXT
Jackie Neale

Hippolyte Bayard, *Arrangement of Specimens, c. 1842*

This image – a cyanotype – was created without a camera. Instead, these specimens were placed directly on light-sensitive paper and exposed to sunlight.

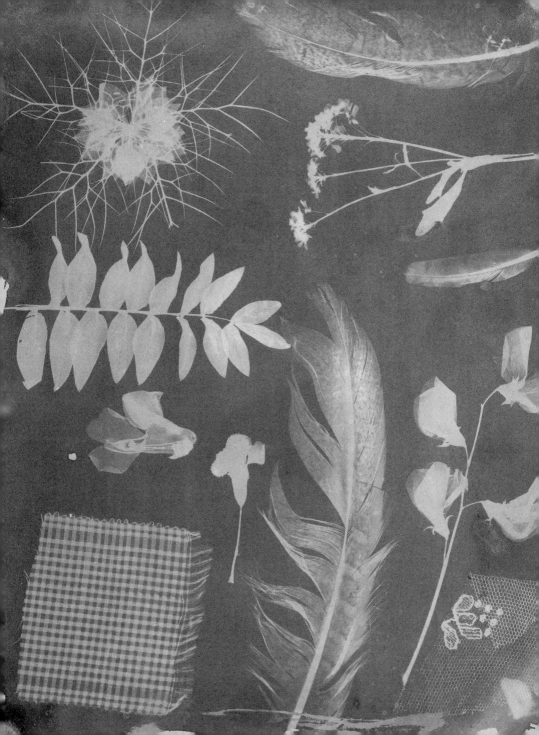

SIZE

the 30-second focus

Size is a visual element that

gives form to an image. Examining the specific components of an image and how they relate to each other builds a visual hierarchy. This is important, as the perceived size of a subject inside of a frame shapes the viewer's overall perception of the image. As humans we need scale to understand how large or small the world around us is, and a subject's size helps to shape this sense of scale. A subject's size may emphasize or draw attention to certain unexpected or exaggerated elements. Size may also help to enforce a focal point, or to abstract an image completely. Observing familiar visual elements allows for the viewer to interpret information about scale, such as the size of a person inside of a landscape or a hand holding an object. Size is a key compositional element controlled by the photographer's technical and aesthetic choices when composing the image. Size and scale are important visual elements that act as a jumping board for discussions about the possible intentions of the creator of the image by examining why they chose to compose the image in a specific way.

RELATED TOPICS
See also
JUXTAPOSITION
page 80

MEANING
page 116

3-SECOND FLASH
Size is a key compositional element of a photograph affecting the viewer's perception and the perceived importance of the elements within an image.

3-MINUTE EXPOSURE
The juxtaposition of different-sized objects in the foreground and the background of an image can help to create depth. An image without any sense of scale creates a feeling of mystery and abstraction. Longer lenses will compress the scene creating interesting shapes, or make mountain ranges feel as big as they look in person. Wide lenses can help keep the whole photograph in focus, inviting the viewer to experience the image as if they were there.

3-SECOND BIOGRAPHIES
JAMES CASEBERE
1953–
American contemporary photographer whose work is made from tabletop constructions referencing architecture, art history and film

BORIS IGNATOVICH
1899–1976
Photojournalist influenced by Russian Constructivism

LAURIE SIMMONS
1949–
American photographer who is known for her use of dolls to replicate domestic scenes

30-SECOND TEXT
Adiva Koenigsberg

Elliott Erwitt, *From the series Dog Dogs, USA, New York City, 1946*

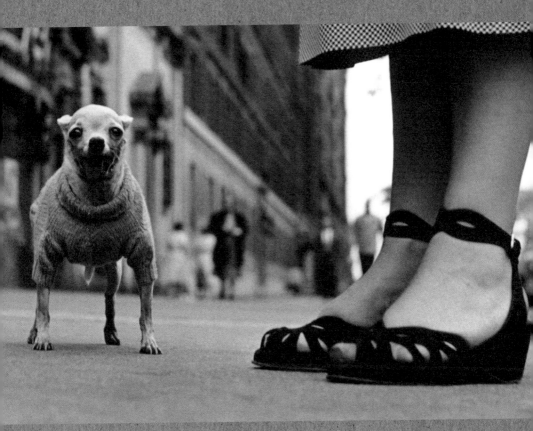

Scaling the composition of this scene down to the eye-level of a chihuahua has played on expectations of the relative sizes of these two subjects, such that the woman on the right appears massive, in a sense.

1925
Born in Ashland,
Wisconsin, USA

1956
Publishes his first book
of photographs, *The
Idea of Louis Sullivan*

1958
Publishes his second
book of photographs,
The Face of Minnesota

1962
Appointed chief curator
of photography at
MoMA (Museum of
Modern Art) in New York
City by Edward Steichen

1964
Publishes
The Photographer's Eye

1967
New Documents
exhibition at MoMA,
featuring the work
of Diane Arbus, Lee
Friedlander and
Garry Winogrand

1976
*William Eggleston's
Guide* – first solo
exhibition of a colour
photographer at MoMA

1978
Mirror and Windows
exhibition at MoMA

1981–85
Series of books and
exhibitions on Eugene
Atget at MoMA

2005
Retrospective of his
photographic work at
SFMoMA (San Francisco
Museum of Modern Art)

2007
Dies at age 81
in Pittsfield,
Massachusetts

JOHN SZARKOWSKI

Photographer, writer and curator

most well known as the Director of Photography
at the Museum of Modern Art from 1962 to 1991,
Szarkowski is defined by some as being the most
influential figure in photography in the second
half of the twentieth century. Born in Ashland,
Wisconsin in 1925, Szarkowski was a prolific
photographer in his early years, receiving two
Guggenheim Fellowships and publishing books
of his work, such as *The Idea of Louis Sullivan*
in 1956, and *The Face of Minnesota* in 1958.

In 1962, at the age of 36, he was selected
by Edward Steichen to be his successor as
Chief Curator of Photography at the Museum
of Modern Art. At the beginning of Szarkowski's
curatorial career, photography was considered
more of a practical medium, and still not fully
embraced as a fine art by curators and critics.
There was not a single commercial gallery in
New York exhibiting photography. Despite these
conditions, Szarkowski described the difference
between his approach at MoMA and that of his
predecessors Steichen and Beaumont Newhall
thus: 'Consciously or otherwise, (they) felt
more compelled than I to be advocates for
photography, whereas I – largely because of
their work – could assume a more analytic,
less apostolic attitude'.

As a result, Szarkowski was free to
actively champion innovative contemporary
photographers with ambitious exhibitions
that often generated controversy. His *New
Documents* show at MoMA in 1967 featured
the work of Lee Friedlander, Diane Arbus and
Garry Winogrand, demonstrating the radical
use of photography as a powerfully personal
approach to engage with the world. In 1976, he
gave William Eggleston the first solo show at
MoMA by a colour photographer. This show, now
thought of as a seminal photographic exhibition,
was met with great criticism at the time. Hilton
Kramer in a *New York Times* review wrote: 'Mr.
Szarkowski throws all caution to the winds and
speaks of Mr. Eggleston's pictures as "perfect".
Perfect? Perfectly banal, perhaps. Perfectly
boring, certainly'.

Two of his books, *The Photographer's
Eye* (1964) and *Looking at Photographs: 100
Pictures From the Collection of the Museum
of Modern Art* (1973), continue to be influential
texts. His suite of books and exhibitions on the
early French photographer, Eugene Atget, helped
redefine the history of vernacular photography.
Szarkowski's legacy is cemented by the
substantial critical engagement photography
has accumulated as a fine-art medium.

HISTORICAL MOVEMENTS

HISTORICAL MOVEMENTS
GLOSSARY

conceptual art An art movement that emerged in the 1960s, giving precedence to concepts embedded in the work rather than technical, formal or aesthetic concerns. An example of this is John Baldessari's series *Throwing Three Balls in the Air to Get a Straight Line (Best of Thirty Six Attempts)* from 1973, where the artist uses every frame from one film roll to photograph three yellow balls against a blue sky. The result is series of images that explore concepts surrounding the camera's ability to suspend time and create documentary systems.

constructivism An art movement originating in Russia in the early twentieth century that envisioned art as a powerful social form, one that was participatory, inclusive and had wide populist ideals. Visually defined by bold shapes, tones and colours, as well as the use of industrial materials.

futurism An art movement from Italy in the early twentieth century crossing mediums to include all forms of art and design, as well as cinema, architecture, music and literature. Interested in freeing Italy from traditional modes of art and thinking, Futurists embraced modernity's new technologies and form.

modernism An overarching term which includes a large variety of art and cultural movements (such as Futurism, Constructivism and Abstract Expressionism, for example), generally occurring after the Industrial Revolution up until the 1960s and 1970s. Modernism can be defined as a distinct break from 'traditional' forms of art and design, favouring new materials, processes and forms. Many aspects of Modernism have rigorous formal concerns which privilege essentials such as form and material.

photo-secession An American group of photographers, formed in 1902 by Alfred Stieglitz, who wished, as written in *Camera Work* in 1903 'to advance photography as applied to pictorial expression'. Seeing photography as a fine art and aligned with Pictorialism, Stieglitz also emphasized that photographs 'must be individual and distinctive', advocating photography as a highly subjective means of personal expression, not as an objective image.

pictorialism An aesthetic movement of the late nineteenth century and early twentieth century where photography visually emulated Impressionist painting through soft focus, textured surfaces and emotional expression of the maker. As a result, pictorialist images are often highly dramatic and theatrical, advocating photography as a sophisticated art medium on par with painting. To achieve specific visual effects, pictorialist images were often softened with filters when photographed or toned in the darkroom.

postmodernism A late twentieth-century art and cultural movement which critiques the formal and idealistic aspects of modernism in favour of context and process-driven concerns, often with political and cultural implications. *Untitled Film Stills* by Cindy Sherman can be seen as a quintessential postmodern work: the photos are described as film stills within the implication of a larger cinematic narrative, specific kinds of movies (Film Noir and New Wave films) are referenced, Sherman 'performs' as a variety of characters, the roles of women in society and cinema are deconstructed, and finally, the viewer of her photos references their own understanding of cinema and photography in response to the work.

straight photography Considered to be objective, without manipulation or subjectivity. This term has existed since the 1880s in regards to an unmanipulated print, and is often associated with modernism, which advocated a 'pure' photography. In postmodernism, ideas of 'pure' or 'straight' photography are under great dispute due to the belief no photograph can exist outside of a social or subjective context.

street photography Popularized by photographers such as Henri Cartier-Bresson, Lee Friedlander and Garry Winogrand, street photography looks to the terrain of the urban landscape. Defined by the energy and chaos found in urban cultures, it came into prominence in the 1930s with the emergence of high-quality small-format cameras, which allowed photographers to shoot discretely.

EARLY PHOTOGRAPHY

the 30-second focus

3-SECOND FLASH
Early photography
is the result of several
inventions, creating a
way to permanently fix
an image made by light
onto a surface.

3-MINUTE EXPOSURE
In 1839, a Daguerreotype
(the earliest photographic
process) took 15–30 minutes
for an exposure, and by
1842, 10–60 seconds. It is
for this reason that sitters
often looked very stiff, as
their head would be fixed to
a board to stabilize them.
A common subject of early
portraiture were deceased
infants, as the infant-
mortality rate was so high
during the second half
of the nineteenth century,
and photography provided
a way for bereaved parents
to have a memento of
their child.

Dating back to the thirteenth–fourteenth centuries, the camera obscura is the prototype for the first analogue cameras. Early photography is a result of several inventions, with the goal of permanently recording images onto a light-sensitive material. Photography's basic principle would not be born until 1826, with Joseph Nicéphore Niépce's invention of such a material that could permanently fix an image onto a surface. The word 'photography' was not coined until 1836 by Sir John Herschel. Derived from Greek, the word means 'drawing with light'. Early technological improvements directly affected the growing popularity and applications of the medium. In the 1850s, portrait studios began appearing around the world, as it was for the first time possible for middle-class people to afford to have their portraits made. Around the same time, negatives that yielded reproducible images and shortened exposure times allowed not only the inhabitants of places to be recorded, but their movements as well. The invention of negatives that did not require instant development made possible the advent of handheld cameras and the recording of the first images of war. Since its beginning, photography has been a synthesis and product of advancements in both art and science, reflecting and observing both through its image.

RELATED TOPICS
See also
DOCUMENTARY &
PHOTOJOURNALISM
page 38

FILM CAMERA
page 56

PORTRAITURE
page 46

3-SECOND BIOGRAPHIES
HILL & ADAMSON
(ACTIVE AS A TEAM)
1843–48
Scottish portrait photographers

LOUIS-JACQUES-MANDÉ
DAGUERRE
1787–1851
French inventor of the
Daguerreotype, a process
of photography that greatly
reduced exposure time

ROGER FENTON
1819–69
Pioneering British war
photographer

30-SECOND TEXT
Adiva Koenigsberg

Joseph Nicéphore Niépce,
*View from the Window
at Le Gras, 1826*

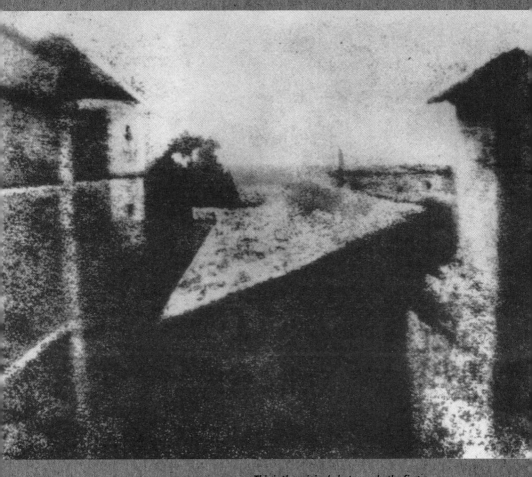

This is the original photograph, the first
image ever recorded by light falling on a
light-sensitive surface. There was no film,
but rather a type of asphalt, on which the
image was focused using a camera obscura.
The exposure time was so long that the sun
is striking the buildings on opposite sides.

VERNACULAR

the 30-second focus

RELATED TOPICS
See also
DENOTATION & CONNOTATION
page 114

MOTIF
page 82

PROXIMITY
page 16

REPRESENTATION
page 20

Meaning 'the language of the everyday', vernacular can refer to everyday verbal language or to functional buildings and objects. In photography, vernacular is similarly associated with subject matter that represents the ordinary, the casual and the everyday. In application, however, it can refer to amateur images such as family snapshots, photo booth prints, studio and school portraits, ID photos, postcards and travel images. As a result, it often has a close relationship to found photographs – discarded or second-hand images found or bought at charity shops, car boot sales or online. These photographs now have common use as source material curated into various art projects, exhibitions and archives. Another association with the vernacular is the group of fine art photographers who photograph everyday elements around them. One example is Walker Evans, who developed a democratic way of looking at subjects to photograph, with subject matter ranging from portraits of everyday people to buildings and street signs. In a contemporary context, the vernacular photograph is what saturates social-media websites. Selfies, images of children and pets, food, travel images and details of the everyday are the photographs most commonly produced and shared.

3-SECOND FLASH
Images of the ordinary and everyday are now everywhere on social media as people visually document the details of their lives.

3-MINUTE EXPOSURE
Vernacular photography emerged as the dominant form when the film camera became widely available, with the introduction of Kodak's Brownie camera in 1900. Since that time, how vernacular photographs look have undergone major changes due to technology and photographic behaviour. With different applications available on the computer or smartphone, the 'look' of certain vintage vernacular photographs (Polaroids, scalloped edges, colour casts etc.) can be simulated, creating a new form of photographic nostalgia and association.

3-SECOND BIOGRAPHIES
EUGENE ATGET
1857–1927
Early French pioneer of vernacular photos

WALKER EVANS
1903–75
American photographer known for his work documenting the effects of the Great Depression

30-SECOND TEXT
Ben Sloat

Frank Gallaugher, *Selfie*

DOCUMENTARY & PHOTOJOURNALISM

the 30-second focus

3-SECOND FLASH
An approach in photography that aims to document the reality of our world, in either single- or multi-picture stories.

3-MINUTE EXPOSURE
Although many claim that Eddie Adams' picture of the execution of the Viet Cong officer in Vietnam, or the burned girl running away from a Napalm bombing from that same war by Nick Ut, changed the way Americans regarded that war, there is no proof that this is the case. It is more likely that by the time public opinion had changed, these images were available to illustrate the case.

Photographers who set out

to document our world with the aim to show things as they are, with as much objectivity as possible, are considered to practice photojournalism. In documentary photography, the starting point is the same, but there is more room for subjectivity. Photojournalism is associated with single-picture stories, whereas documentary photographers create long-term, multi-image photo essays. Photojournalism and documentary have a long history, starting even before the American Civil War, and although the practice continues today, its successes have been mostly associated with the printed media and magazines such as the French *Vu*, American *LIFE*, or British *Sunday Times*. Newspapers such as *The New York Times* published photos about conflicts that reverberated throughout society, such as the famous picture by Eddie Adams of the execution of a Viet Cong officer during the Vietnam War. Some claim it was this image that changed American public opinion on the war. With the demise of printed magazines and newspapers, photojournalism has lost its natural source of income and is currently struggling to find new sources to fund its production. Crowd sourcing and a move to a more narrative approach are now explored as new directions in the post-print economy.

RELATED TOPICS
See also
FOCUS
page 22

NARRATIVE PHOTOGRAPHY
page 44

3-SECOND BIOGRAPHIES
EDDIE ADAMS
1933–2004
American war photographer, employed by Associated Press (AP)

NICK UT
1951–
Vietnamese photographer

30-SECOND TEXT
Marc Prüst

Eddie Adams,
Saigon Execution, 1968

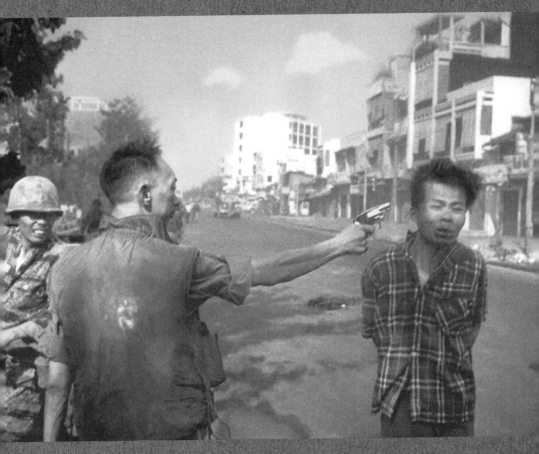

'Two people died in that photograph: the recipient of the bullet and General Nguyen Ngoc Loan. The general killed the Viet Cong; I killed the general with my camera. Still photographs are the most powerful weapon in the world. People believe them, but photographs lie, even without manipulation. They are only half truths.'
– Eddie Adams, 'Eulogy', Time, 27 July 1998.

Adams was sympathetic to General Loan's position and apologized for the effect the photo had on his career and reputation. The general himself eventually moved to America and opened a pizza restaurant in Washington DC, where he remained until he died of cancer at age 67. In this eulogy written for Time, Adams called the general a hero.

LANDSCAPE

the 30-second focus

3-SECOND FLASH
Initially associated
with painting, landscape
photography has changed
with photographic
technologies, ease of travel
and inclusion of human
impacts as subject matter.

3-MINUTE EXPOSURE
During the Industrial
Revolution, the landscape
was often photographed
with a romantic yet
practical eye, describing
its wildness and vast
potential for human use.
In a contemporary setting,
landscape photographers
like Richard Misrach and
Edward Burtynsky have
often shifted their focus
to the dramatic effects of
human impact on the land.
These images create a new
form of beauty and visual
intrigue, one that can be
startling and unsettling.

Generally described as photos

where the central representation is a place, often associated with the photographing of nature without human subject matter or activity, landscape photography has evolved greatly, due to the evolution of technology and with the greater acceptance of photography as a fine-art form. Initially, landscape photographers were encumbered by bulky equipment, which did not prevent certain enterprising photographers in the mid- and late-nineteenth century from travelling to exotic locations, but did necessitate a contingent of helpers and other support. Visually, landscape photography was once heavily influenced by painting, and often referenced painting in composition, subject matter, romantic approach or soft palette. A great shift happened with photographers like Ansel Adams and the group f/64, who used the camera to its full technological potential in terms of focus, contrast and sharpness. Their subject matter often looked at details within a landscape, regarded the philosophical aspect of the land or explored the environmental potential of preserving wilderness. In the contemporary era, landscape photography has since evolved to include abstractions of the land, aerial perspectives and the inclusion of human development and activity.

RELATED TOPICS
See also
LENS
page 54

LINES
page 78

MOTIF
page 82

QUALITY OF LIGHT
page 98

VANTAGE POINT
page 74

3-SECOND BIOGRAPHIES
ANSEL ADAMS
1902–84
American innovator of landscape photography

EDWARD BURTYNSKY
1955–
Well-known contemporary Canadian photographer

30-SECOND TEXT
Ben Sloat

Brian Dilg, *Treeline, Pennsylvania*

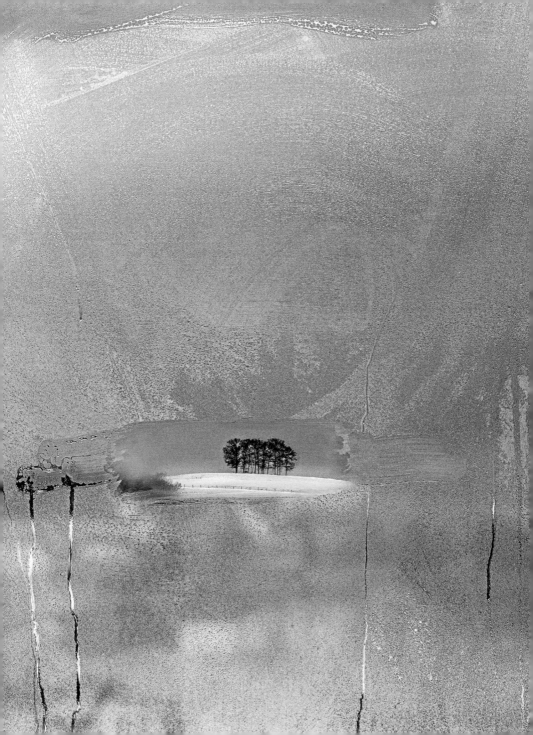

COLOUR PHOTOGRAPHY

the 30-second focus

3-SECOND FLASH
The colour photographic process, available on a wide scale in the 1930s with the Kodachrome, truly gained in mainstream popularity in the 1960s and 70s.

3-MINUTE EXPOSURE
Early uses of colour photography include the fascinating set of images from 1939 to 1944, made with Kodachrome, of rural America and Puerto Rico. Produced through the Farm Securities Administration, which hired top photographers of the day to educate the larger American public about the plight of poor rural farmers, these photographs provide a unique colour view of lifestyles usually seen in black and white.

Colour film became widely
used with the introduction of a slide film called Kodachrome in 1935. Designed for a 35mm film camera, the finished roll would be mailed to Kodak, processed, and a box of slide transparencies would be mailed back, able to be presented with a slide projector. Kodachrome would be available in print form in the early 1940s, though its cost was far greater than black-and-white prints (Kodachrome was discontinued in 2009). By the 1960s, instant colour films were popularized by Polaroid, providing ease of use for making colour prints. At the same time, colour 35mm negative film became much more affordable, and replaced black and white as the most common form of photography. In the fine art realm, where colour photography had been considered more as a commercial medium, shifting attitudes came with the prominence of photographers working in colour such as William Eggleston and Stephen Shore in the 1970s. With the rise of digital photography in the twenty-first century, the use and output of colour photography has become ever more diverse and sophisticated.

RELATED TOPICS
See also
COLOUR OF LIGHT
page 106

DAYLIGHT
page 100

REPRESENTATION
page 20

VERNACULAR
page 36

3-SECOND BIOGRAPHIES
WILLIAM EGGLESTON
1939–
Influential colour photographer

STEPHEN SHORE
1947–
American photographer famous for capturing mundane towns and streets in vivid colour during his cross-country road trips

30-SECOND TEXT
Ben Sloat

Jack Delano, *Barker at the Grounds at the Vermont State Fair, 1941*

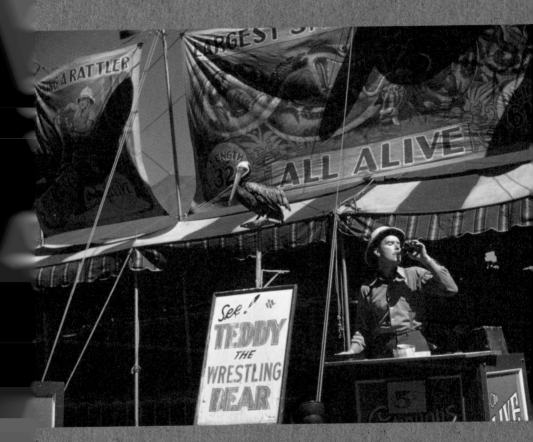

While we rationally know colour existed before it was ever captured on film, there is a cultural bias to imagine certain eras in grainy, faded, monochrome tones. Bright, colourful shots like this go against the accepted narrative of the Great Depression as a dreary, barren landscape.

NARRATIVE

the 30-second focus

3-SECOND FLASH
Narrative photography is the power to tell a story, to lead the viewer from a beginning to an end through one or more images.

3-MINUTE EXPOSURE
Not every picture series is a narrative, but you can tell stories in various ways – without a climax, even. Combining a multitude of similar pictures that depict similar but very slightly different objects – like the Bechers' water towers – is known as a 'typology'. A set of images in which each single photograph represents one particular aspect of a theme or subject is a 'portfolio'. Within photography these sets are still stories, but they don't qualify as narratives.

Can one single moment, a fraction of an event as represented in a photograph, impress on the viewer the complexities of a narrative? And what is, in fact, a narrative? If you consider narrative as a way to tell a story, and you define the story as something with a beginning, middle, climax and end (not necessarily in that order), then at least you will need a series of photographs in order to talk about narrative photography. Documentary photographers often use narratives to convey the stories of the events they cover. W. Eugene Smith became famous for his long-term engagement with communities in Spain, the US and Japan, that resulted in photographic narratives that were published in magazines such as *LIFE*, or as books. Some photographers work in such a way though that an entire story can be read in one single frame. American photographer Gregory Crewdson, for example, constructs complete film sets with large teams of assistants and productions crews to create a single image that at first sight seems simple and straightforward. The longer you look, however, the more details you will see, and you will be able to construct a story.

RELATED TOPICS
See also
DENOTATION & CONNOTATION
page 114

FRAME
page 14

DOCUMENTARY &
PHOTOJOURNALISM
page 38

REPRESENTATION
page 20

3-SECOND BIOGRAPHIES
GREGORY CREWDSON
1962–
American art photographer

W. EUGENE SMITH
1918–78
American documentary photographer

30-SECOND TEXT
Marc Prüst

W. Eugene Smith, *Lorenzo Curiel in White First Communion Dress Waiting for her Mother to Lock the Door (from* Spanish Village*), 1950*

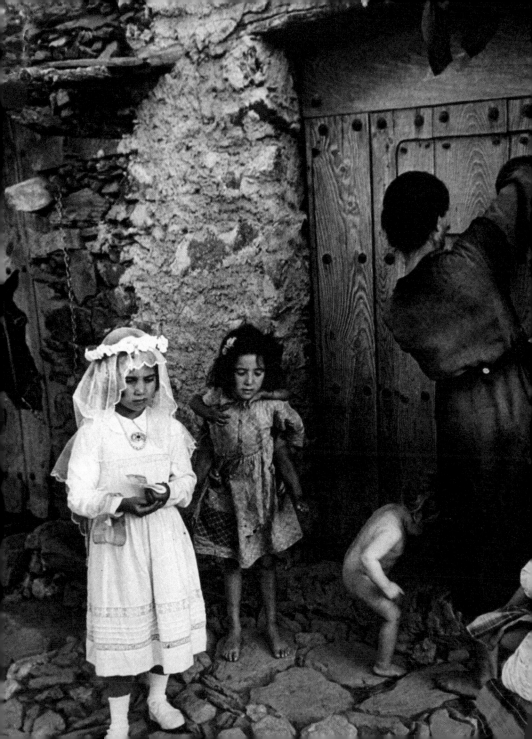

PORTRAITURE

the 30-second focus

3-SECOND FLASH
Portraits, initially reserved
for a minority of people who
could afford them, became
hugely accessible and
popular with the invention
of photography.

3-MINUTE EXPOSURE
Portrait photography
evolved quickly from
straight-on stoic portraits of
an elite group of participants
to amateur portraits
easily made to simply
commemorate someone's
likeness. Portrait
photographs were seen as
mirrors of 'truth' because
of the realistic nature of
the photograph as opposed
to presumably interpretive
paintings. Ironically, digital
portraits can now be
embellished even more
easily than paintings of
the past. Manipulation of
digital photographs makes
portraits a form of artistic
expression beyond a mere
realistic capture.

Portrait photography was born
nearly as soon as the invention of the first
photographic process, the daguerreotype. Prior
to photography, portraits were reserved only
for people who could afford to commission them,
and were often embellished to accentuate
iconography or symbols of rank. Though initially
an expensive prospect, photography soon made
portraits more widely accessible. Early processes
required long exposures, therefore most portrait
photographers were based in large studios
flooded with natural light. By 1851 with several
new options like the tintype, glass plate and
paper negatives, portrait photography became
less expensive and more commonplace. By 1863
professionals and amateurs alike were creating
and exhibiting portraits, but it was with the 1888
invention of the Kodak #1 camera by George
Eastman that the popularity of photography
soared. The Kodak #1 was a simple box preloaded
with film that could be sent to the Kodak lab for
processing and printing, and returned reloaded
with a fresh roll of film. As handheld cameras
evolved, portraiture expanded beyond the
professional realm, and became extremely popular
in the amateur photography world. Throughout
the history of photography, portraiture has been
a cornerstone to the medium's popularity.

RELATED TOPICS
See also
MEANING
page 116

CONTEXT
page 124

3-SECOND BIOGRAPHIES
JULIA MARGARET CAMERON
1815–79
A fine-art portraitist from
Britain, known for her images
of artists, writers, family and
friends in the late 1800s

RICHARD AVEDON
1923–2004
An American photographer
well known for his commercial
portraits of politicians,
celebrities and models

30-SECOND TEXT
Jackie Neale

Julia Margaret Cameron,
Beatrice, 1866

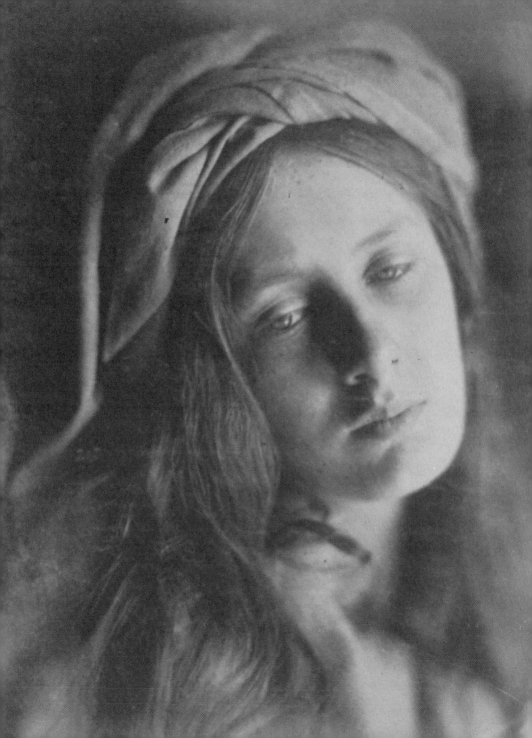

Rhein II, 1999

1955
Born in Leipzig,
(formerly East) Germany,
the son of a commercial
photographer

1977–87
Studies photography
with Otto Steinert, and
Bernd and Hilla Becher

1985
First exhibition

1988
First solo gallery show
at Galerie Johnen &
Schöttle, Cologne

1990
Exhibited at Venice
Biennale

1996
Exhibited at Sydney
Biennale

1998
First one-person
museum exhibition in
the United States at
Milwaukee Art Museum

2001
Retrospective exhibition
organized by Museum of
Modern Art, New York

2007
99 cent II Diptychon
(1999), an image of
a supermarket interior,
sells at Sotheby's for
$3.3 million, then the
highest price ever paid
for a photograph

2011
Rhein II sells for $4.3m,
breaking the record
for most expensive
photo ever sold

ANDREAS GURSKY

To stand before a Gursky image

is to be overwhelmed by scale and detail. Always working with extraordinarily large prints, composed with utmost formality, often from high vantage points, Gursky's images announce themselves on a grand scale that suggests that something vastly important must have motivated the considerable trouble he goes to in order to create each photograph. (He has been known to spend a year on digital post-production, painstakingly assembling multiple large format images together to invent what he has called 'a condensation of reality'.) And yet the images defy the viewer to single out a definitive meaning, a decisive moment, a singular subject or story. His narrative is modern existence itself, along with all of its technologically driven impersonal detachment.

Vast numbers of people crowd factory floors, stock markets, beaches, enormous concert halls, sports stadiums and race tracks. We can identify only the broadest groups by the colour of their uniforms, but no single individual or action emerges. Expensive shoes or cheap, nauseatingly colourful commodities line endless shelves. Floors, windows and doors repeat themselves as far as the eye can see. Pit crews hovering over elite race cars are presented with all the formality and drama of a Caravaggio painting, but above them are spectators behind a glass wall, many of them taking pictures.

Meanwhile, a vast glacier creeps imperceptibly along. A familiar river rolls by, and will do so long after we're gone. (Gursky hints as much by digitally removing all but a few signs of civilization from its banks.)

This is the world we have built, yet we rarely step back and truly see it; we are lost in it. In his work since the 90s, digital manipulation heightens the unreal quality of these worlds that are so familiar and banal – so why do they astonish us so when presented as an image? This is the power of art, to reveal to us what is right under our noses, that which creeps up on us and surrounds us and which we most overlook. Who would stop to just look out over a pound shop with its overwhelming array of products all screaming for our attention? We are a long ways from Ansel Adams territory here; we are not being asked to notice the beauty of the world. Looking down as if divine creators, we are shown what we have made, and what we cannot make, but might just destroy.

Yet the artist's position remains enigmatic. As he says, 'I think my images are neutral'.

Gurksy lives and works in Düsseldorf.

CAPTURING THE IMAGE

bit depth The number of binary digits of information recorded in an image. Modern digital cameras capture 12 to 16 bits of possible values of red, green and blue (each called a 'channel') using the Raw format, which is 4,096 to 65,536 possible values per channel, or roughly 68 billion to 281 trillion possible colours. Higher bit depth means an ability to resolve more subtle differences in colour and tone, thus smoother results. Most digital colour image editing and printing is done in 8-bit colour space (16,777,216 possible colours, including all JPEGs). Sixteen bit editing space produces substantially larger files, but provides a significant improvement in image quality.

clipping In imaging, when a signal exceeds the mathematical limits of a digital sensor. For example, any signal translated to zero on all three colour channels produces pure black; any signal weaker than that is still recorded as black, as zero is the lower limit of the sensor's scale. Any signal higher than the highest possible value is recorded as pure white. Clipping means the original detail in a scene is recorded only as pure white or black because it exceeded the sensitivity limits of the system. Detail cannot be recovered from clipped areas later, thus the importance of determining clipping at the time of exposure.

colour temperature A scale used to measure one component of colour: its hue on a warm-cool scale. Measured in degrees Kelvin, it refers to 'warm' colours (reddish) to 'cool' (bluish). Industry standards for electric lights include 5500K ('daylight') and 3200K ('tungsten'). The colour temperature of daylight can range widely from upwards of 20,000K on a very cloudy day (very blue) to below 2000K at sunrise or sunset (very red).

dynamic range Also known as exposure latitude, this describes the range of intensity of light that can be recorded by an imaging system in a single exposure before its limits are reached, beyond which no detail is recorded. Measured in stops, today's state of the art digital cameras using the Raw format can typically handle an 11–13 stop range of contrast before clipping.

F-stop A full 'stop' change means that the intensity of light has been doubled or halved. The relationship between light and all three components of exposure (aperture, shutter speed and ISO) is expressed in terms of full or partial stops. 'F-stop' specifically refers to aperture, which is the ratio between the diameter of the aperture in the lens and the focal length of the lens, thus how much light is admitted.

JPEG Joint Photographic Experts Group who created a standard for producing small, compact files optimized for electronic transmission through the use of lossy compression. The greater the compression, the smaller the file, but the lower the quality. Highly compressed files demonstrate visible artefacts that hint at the algorithm underlying the compression scheme, but the JPEG algorithm can achieve a remarkable reduction in file size before such artefacts become obvious.

raw format A digital image file format produced by digital cameras or scanners, designed to capture as accurately as possible the physical intensity and colour of light. Sometimes referred to as 'digital negatives', Raw files are not quite images, as they must be interpreted through a number of software algorithms to become viewable, editable or printable. They are notable for containing minimal processing; for instance, they have no permanent commitment to white balance, saturation or contrast. Vastly superior in quality to any other file format currently available, they are significantly larger than formats such as JPEG or TIFF, and they are never permanently changed by processing; a copy is always extracted while the original remains untouched.

resolution The degree of detail an imaging system is capable of capturing. In the case of digital photography, this is a function of how many pixels an image sensor records, or the number and density of pixels within a physical print. The physical size of a sensor places limitations on how many discrete pixels can be fit onto it. With respect to a print, resolution is more flexible, as the larger the print, the farther away viewers typically stand. Billboards, for instance, typically have 10–15 pixels per inch. Prints intended to be viewed at arm's length in a publication are commonly printed around 300 pixels per inch.

zone system An exposure methodology developed by Ansel Adams and Fred Archer around 1939–40 to better match the contrast range of a scene to the exposure latitude of a film negative. The technique is based on the fact that during the chemical development process, shadows develop very quickly, whereas the brightest highlights take the longest. Thus shadow areas must be exposed as desired at the time of exposure, but highlight detail can be controlled to a certain extent (about plus or minus two stops in practice) by varying development time. Thus the original contrast of a scene can be expanded or compressed onto a film negative by a combination of exposure and development time.

LENS

the 30-second focus

Attached to the front of the

camera, the optical lens is typically convex, produced of glass and other lens elements, such as shutter and aperture, within a plastic or metal housing. Lenses control focus via either manual adjustments or automatic motors which drive the elements into position. The lens also regulates the amount of light that enters the camera through the speed of the shutter in the camera, as well as the size of the aperture. The aperture of the lens affects depth of field, which is the range of the photographed scene able to be rendered in acceptable focus. Lenses can be fixed on the camera, or interchangeable, as with most SLR formats (both film and digital) and large format cameras. Regulating the camera's relationship to the subject, lenses can be macro, wide angle, normal, zoom or telephoto, which produce enormous differences in capturing a particular angle of view, perspective, composition and other visual content through the camera. On most large-format cameras, lenses can tilt and shift away from being parallel to the film or sensor, creating unique distortions and focus effects.

3-SECOND FLASH
The optical device on the front of the camera that controls focus and regulates the amount of light which enters the camera.

3-MINUTE EXPOSURE
With the popularity of diverse imagery in contemporary use, a variety of lenses can be purchased for digital and film SLRs to create deliberate blurs, colour shifts, toy camera effects, lens shifts and fisheye effects. Many lenses with similar effects can even be purchased for camera phones. Filters can also be mounted to the front of lenses to create a variety of visual effects.

RELATED TOPICS
See also
FRAME
page 14

FIGURE/GROUND
page 76

LINES
page 78

TIME
page 18

VERNACULAR
page 36

3-SECOND BIOGRAPHIES
WILLIAM TAYLOR
1866–1937
British inventor who pioneered many lens improvements

CARL ZEISS
1816–88
Founder of company making high-quality lenses

30-SECOND TEXT
Ben Sloat

This cross section of a Zeiss Distagon 21mm f/2.5 lens shows just how complex even a prime lens can be.

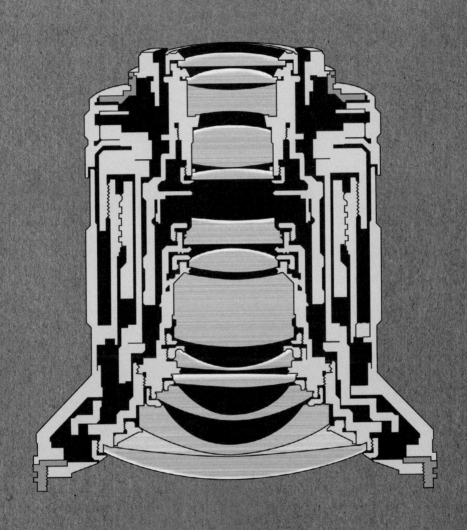

FILM CAMERA

the 30-second focus

A film camera records images

onto a light-sensitive emulsion to produce either a negative or positive analogous image of a scene. Images cannot be viewed immediately, as film remains sensitive to light until processed with special chemistry. A reflex camera reflects a scene from a mirror onto a viewing screen, commonly seen through a viewfinder, so that composition and focus can be assessed. When the shutter is released, the mirror is raised and light is directed through the lens onto the film, converting photos to a latent image. A twin lens reflex (TLR) camera uses two lenses with the same focal length, one used for focusing light onto the film, and the other used to focus and compose the image. With a rangefinder camera, composition and focus are gauged through a small, separate lens. Formats (film sizes) invented since the invention of the medium diminished over time from very large single plates or sheets ('large format', typically 4×5" or larger) loaded one at a time, to medium format (cameras based on a 6cm-wide roll of film, used by many professionals prior to digital), to the dominant popularity of 35mm-wide perforated rolls (which record a 24×36mm image), to even smaller roll formats. The 35mm format became the basis of today's popular 'full frame' digital cameras.

3-SECOND FLASH
A film camera records latent images onto light-sensitive material, which appear after chemical processing.

3-MINUTE EXPOSURE
The origins of the film camera date back to a fifth-century discovery by the Chinese philosopher Mao Toi, who found that a pinhole can form a focused, inverted image inside of a dark space. Though film cameras have become quite sophisticated, the three essential elements remain: a light-tight box with a means to mount film, a focusing lens and a shutter which regulates light passing through.

RELATED TOPICS
See also
EXPOSURE
page 58

FORMAT
page 66

LENS
page 54

3-SECOND BIOGRAPHIES
ALHAZEN (EGYPTIAN)
965–1040
Inventor of the camera obscura

GEORGE EASTMAN
1854–1932
Founder of Eastman Kodak

JOHANN HEINRICH SCHULZE
1687–1744
Discovered a chemical that darkens in the presence of light

30-SECOND TEXT
Adiva Koenigsberg

Clockwise starting at the top: an early SLR, a twin-lens reflex, a large-format view camera and a rangefinder camera.

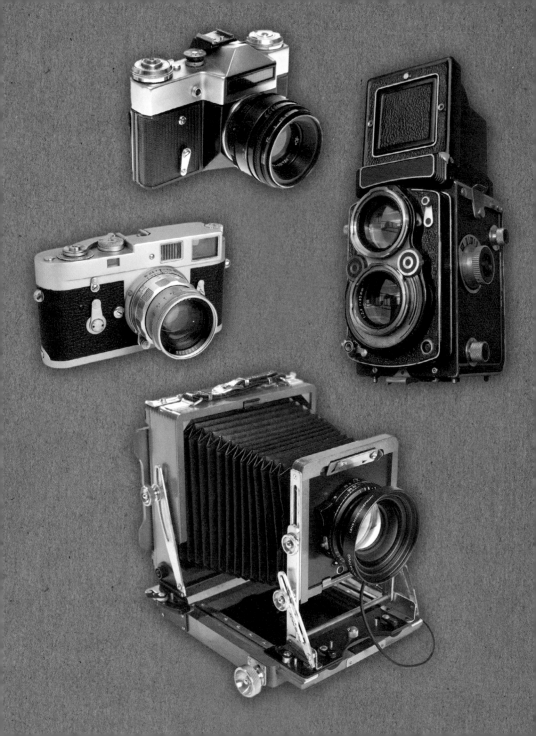

EXPOSURE

the 30-second focus

3-SECOND FLASH
Exposure refers to the amount of light gathered in an image, which is determined by varying ISO (sensitivity), aperture (the opening) and shutter speed (time).

3-MINUTE EXPOSURE
Photography quantifies light in 'stops'. One stop darker means half as much light; one stop brighter, twice as much light. Since it is very often desirable to change aperture, shutter speed or ISO for aesthetic reasons, the same exposure can be kept by compensating by the same number of stops using one of the other two components, i.e. when it comes to light captured, stops are stops. The three components have a reciprocal relationship.

'Exposure' refers to how brightly an image is rendered. This is determined by how much light is allowed to enter the camera, and how sensitive the photographic medium is (be it a strip of film or a digital sensor). A camera is essentially a black box that keeps light out. Exposure is determined by varying the sensitivity of the medium (measured on a scale called ISO), how large the aperture is (an opening into the camera, typically a lens) and how long light is allowed to flow into the camera (the shutter speed). While the human eye adjusts automatically to light, revealing only a normalized view, a camera provides complete control over exposure, and thus over how the tones of a scene are rendered. For example, black can be rendered as black, but it can also be rendered any shade of grey – or even white. While photographers frequently adjust exposure to create images that look similar to what they see with their eyes ('normal' or technically correct exposure), skilful practitioners exploit the unique capabilities of the medium to create more subjective, expressive impressions, well beyond exposure norms, but which still will be accepted by viewers as 'photographic'.

RELATED TOPICS
See also
LIGHT & LIGHTING
page 90–109

TONAL ADJUSTMENTS
page 142

3-SECOND BIOGRAPHIES
ALFRED WATKINS
1855–1935
Inventor of the first commercially successful light metre, the Watkins Bee Meter – so called for its diminutive size

30-SECOND TEXT
Brian Dilg

Brian Dilg, *Blizzard in Brooklyn, 2010*

A reflective light metre would have responded to this scene by grossly underexposing, making the snow grey and the underside of the bridge pure black. This is a classic scenario in which control should be taken away from the camera.

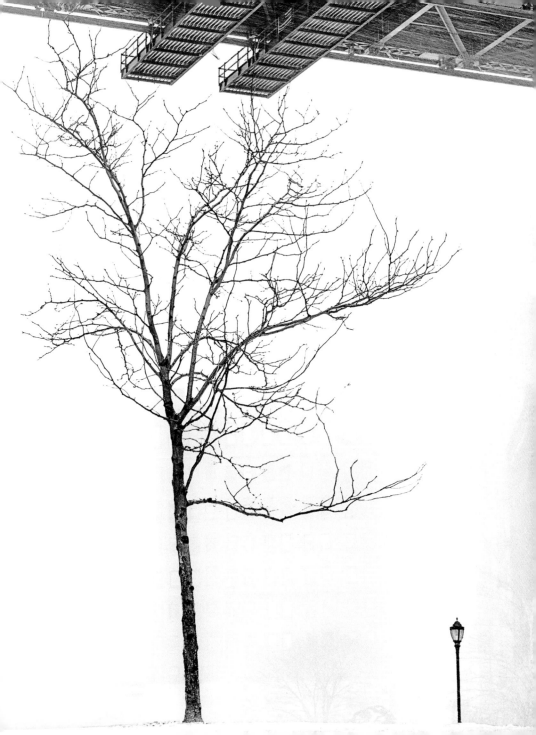

COLOUR RENDITION

the 30-second focus

3-SECOND FLASH
The ability of various photographic technologies, digital or analogue, screen or print based, to demonstrate and reproduce colour.

3-MINUTE EXPOSURE
There continues to be ongoing debate on the technical side of photography regarding the ideal colour rendition of analogue processes, from negative to colour print, or digital processes, from digital sensor to digital print. Furthermore, the scanning of film into digital provides yet another variable for colour rendition. This debate is a recognition of the expanding colour vocabulary of photography, changing with technology, which proposes increasing variables and opportunities in working with colour.

Describes the abilities of various technical methods to consider, produce or reproduce colour. 'Gamut' is a term used in photography referring to the range or set of colours able to be represented by a certain technology, whether digital or analogue. When gamut is combined with a colour model such as RGB (Red, Green, Blue) for light-based technologies, or CMYK (Cyan, Magenta, Yellow, Black; the K, incidentally, stands for 'key') for print-based technologies, a colour space can be defined. RGB is known as an additive colour model, used in television, projectors, scanners, digital cameras and computers, where the blending of red, blue and green produce the colour array. CMYK is a subtractive colour model used for ink or chemical based colour printing (colour darkroom, offset printing, inkjet printing), where the colour array is produced when CYMK 'subtracts' from a white base. In accordance to their processes, the combination of colours in the RGB produces white, while the combination of CYMK produces black. In digital cameras, using colour digital sensors or monochromatic sensors with filters provide additional input choices for colour rendition.

RELATED TOPICS
See also
COLOUR OF LIGHT
page 106

COLOUR PHOTOGRAPHY
page 42

VERNACULAR
page 36

3-SECOND BIOGRAPHIES
ALBERT MUNSELL
1858–1918
Inventor of the Munsell colour system

30-SECOND TEXT
Ben Sloat

By taking a photo of this colourchecker and running it through its paired software, you can create profiles that ensure precisely accurate colour rendition in the finished print.

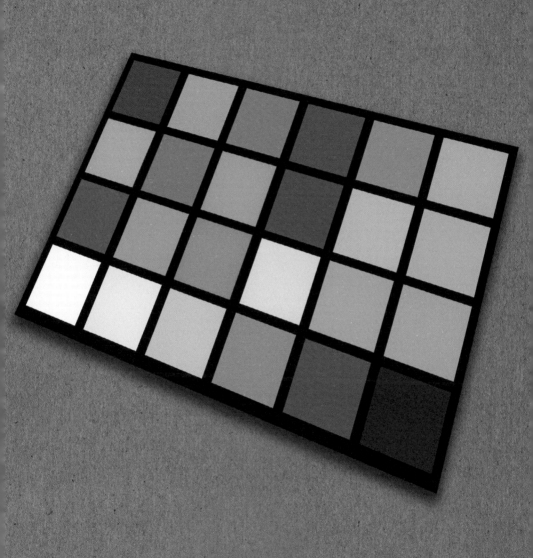

STROBE LIGHTING

the 30-second focus

3-SECOND FLASH
Photographers prefer
strobe lights when available
light sources are not strong
enough or cannot provide
enough lighting control
on set.

3-MINUTE EXPOSURE
Strobe lighting allows
a photographer to shoot
with control over lighting
aesthetics and exposure.
Strobes permit lower ISO
ratings and greater depth
of field. Having such
flexibility, a photographer
is able to photograph
with greater detail and
more accurate colour.
Strobe lights give serious
photographers the ultimate
in control in and out of the
studio, and provide much
greater flexibility than
available light.

Strobe lights are electronic light sources often used by photographers to create specific looks, or when there is inadequate ambient light. Strobes provide very short, powerful bursts of light coinciding with a camera's shutter release. Studio strobe systems also usually have a continuous modelling light that allows the photographer to simulate the strobe light. On-camera and portable flashes are also called strobes. They are portable, convenient and run on batteries, but provide far less light and no modelling light. Principles of using portable and studio strobes are virtually the same, but there are practical differences. Portable strobes are excellent for location photographs such as parties, street photography and weddings. However, they do not easily connect to hardware used to shape the quality and direction of the light: softboxes, beauty dishes, reflectors, grids etc. – all standard accessories for studio strobes. Studio strobe systems are considerably more powerful than portable units, recycle far more quickly and are much more expensive. Advantages over continuous lights include high output for little power usage and a colour temperature that mixes well with daylight; the prominent disadvantage is that one cannot see what the light will look like until the picture is taken.

RELATED TOPICS
See also
LIGHT & LIGHTING
pages 90–109

TIME
page 18

3-SECOND BIOGRAPHIES
HAROLD 'DOC' EDGERTON
1903–90
Scientist, inventor and professor
at MIT. Commonly known for his
use of stroboscopic photography

DAVID HOBBY
1965–
Known as 'The Strobist', he
revolutionized the use of
on-camera and hand-held
flash in the professional
photography realm

30-SECOND TEXT
Jackie Neale

Harold Edgerton, *Gussie Moran,
Tennis Serve, 1952*

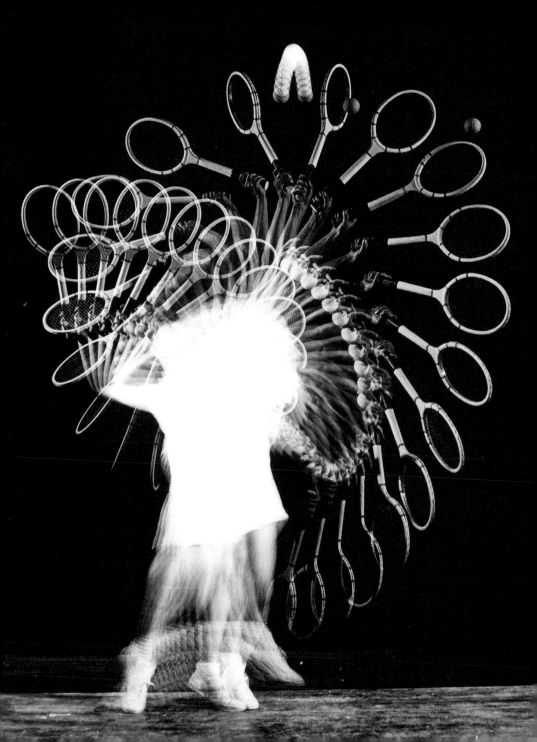

DIGITAL CAMERA

the 30-second focus

3-SECOND FLASH
Digital cameras record a
grid of square pixels, each
containing a colour. Bit
depth determines how
many discreet colours
can be resolved.

3-MINUTE EXPOSURE
A common misconception
about digital cameras is
that the screen conveys
the truth about exposure.
In fact, Raw files cannot
be displayed on a monitor
as-is. A viewable copy must
be generated by applying
adjustments, including
contrast, colour and white
balance. Even if JPEGs
are disabled, the image
displayed in-camera is
always a JPEG generated
from the Raw through
widely variable user
settings, and the
histogram reflects the
tones in that JPEG.

A digital camera uses an

electronic sensor (as opposed to photochemical
film) that converts light into an electronic signal.
The sensor records an array of square pixels into
a digital file, noting colour, brightness and the
position of each pixel. The more pixels a sensor
has, the larger the file will be, and the more detail
is recorded – and usually the more expensive
the camera will be. While the most obvious
advantage of digital capture may be the ability
to view the image immediately on a monitor, and
the cost savings without film and chemistry, it
also captures a wider range of tones than film.
Through the use of the Raw format, it's also
able to record the basis for a broader range of
interpretations than from a film negative. The
popularity of affordable, high-quality digital
cameras was facilitated by the simultaneous
growth of the internet, which has diminished
the time from capture to global distribution to
a matter of seconds. Almost all digital cameras
can also record files in the highly portable,
compressed JPEG format, which facilitates
this electronic distribution.

RELATED TOPICS
See also
FILM CAMERA
page 56

RAW CONVERSION
page 146

3-SECOND BIOGRAPHIES
WILLARD BOYLE
1924–2011

& GEORGE E. SMITH
1930–
The co-inventors of the
charge-coupled device (CCD) –
the first digital imaging sensor,
developed while the pair were
working at Bell Labs in 1969

30-SECOND TEXT
Brian Dilg

*Digital SLRs still use
the same mechanics as
their film predecessors,
simply replacing the
film strip with a sensor.
However, newer
designs eliminate
the mirror and prism
entirely, reading the
image preview directly
off the sensor.*

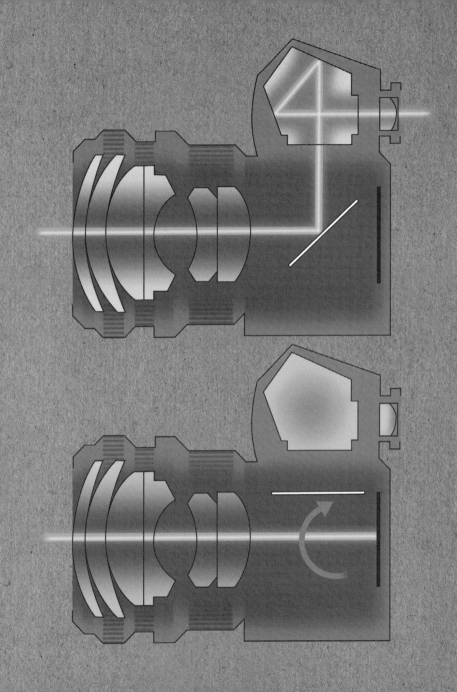

FORMAT

the 30-second focus

3-SECOND FLASH
Format refers to the size and shape of film in a film camera, or the size and shape of an image sensor in a digital camera.

3-MINUTE EXPOSURE
The most common film size is 35mm, and was the standard for photojournalism until the widespread proliferation of high-resolution digital cameras. Large-format film with a 4x5", 8x10", or even larger negative is still the preferred format for serious landscape photographers because of the fine image detail captured. Common sizes for digital image sensors include 1/3.2" found in most smart phones, 1/2.7" in compact cameras, and 1.5" (24x36mm 'full frame') in high-end SLRs.

With regard to film, format describes the size and shape of an image. Film formats are named by their physical size, and are usually described by their width. The larger the format, the more surface area is provided for the image to be created, and the more sharpness and detail is available for reproductions and enlargements of the image. The most common film format is 35mm; anything larger is considered medium format (based on a 6cm wide roll standard) or large format (single sheets typically a minimum of 4×5"). Film format standards determine which types of cameras house specific types of film as well as how many exposures are possible from a single load. Digital photography format refers to the shape and size of the digital image sensor. The bigger the image sensor, the more information is captured, and the better the image quality. In all cameras, the format size (film or digital sensor) also determines the angle of view and magnification of a given lens. As format size increases, so too must the camera body and the lens that can cover the format's surface.

RELATED TOPICS
See also
FILM CAMERA
page 56

3-SECOND BIOGRAPHIES
RICHARD AVEDON
1923–2004
American large-format portrait photographer

LEE FRIEDLANDER
1934–
American photographer, famous for photographing the urban landscape during the 1960s and 70s in 35mm black-and-white film

30-SECOND TEXT
Adiva Koenigsberg

Sensor technology is constantly improving, which benefits smaller sensors in particular – their capabilities steadily rise to the level of previous generations' larger formats, while maintaining their lower price point and greater portability.

35mm 'Full Frame' (36x24mm) Found in high-end professional cameras, based on the 35mm film strip, with a 3:2 aspect ratio

APS-C Found in amateur and enthusiast cameras, with the same 3:2 aspect ratio as 35mm, but 1/3 smaller. So a 50mm lens on an APS-C sensor acts like a 75mm lens on a 35mm sensor

Micro Four Thirds Used by Panasonic and Olympus in their line of mirrorless cameras. It has a 4:3 aspect ratio and is about half the size of a 35mm frame.

1 inch Not actually one inch at all, but rather 13×8.8mm, this format is used in advanced compact cameras

1/1.7 inch Point-and-shoot, entry-level compact cameras

1/3.2 inch Mobile phone cameras

6 April, 1903
Born in Fremont,
Nebraska, United States

1925
Graduates from
University of Nebraska
at Lincoln with
Bachelors of Science in
electrical engineering

1927
Obtains Master's Degree
in electrical engineering
from Massachusetts
Institute of Technology
(MIT)

1928
Marries May Garrett

1928
Becomes instructor of
electrical engineering
at MIT

1931
Receives his PhD
from MIT

1934
Appointed professor
of electrical engineering
at MIT

1937
Edgerton's photograph
of a drop of milk
exhibited in Museum
of Modern Art's first
photography exhibit

1939
*Flash! Seeing the
Unseen by Ultra-High-
Speed Photography*
published

1941–44
Works with the US Army
to create a camera fitted
with flash to illuminate
the ground from the sky.
The cameras were
deployed from an A-20
plane over enemy
territory on the night of
5–6 June, 1944, before
the invasion of France

1947
First article published
in *National Geographic*:
Hummingbirds in Action

1952
Begins work with
Jacques-Yves Cousteau
to photograph the
sea floor

1956
Selected as Fellow of
the American Academy
of Arts and Sciences

1961
Invents an acoustic
sonar device that could
sense objects on the
floor of the ocean called
'the boomer'

1973
Awarded the National
Medal of Science

1987
National Geographic
highlights Edgerton's
work in the article *Doc
Edgerton: The Man who
Made Time Stand Still*

4 January, 1990
Dies at the age of 86

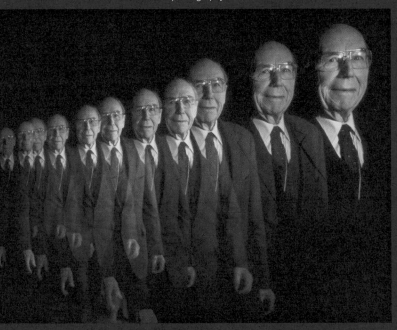

HAROLD EUGENE 'DOC' EDGERTON

Born in Fremont, Nebraska,
in 1903, Edgerton was a scientist, inventor,
photographer and pioneer in stroboscopic flash
photography while working as a professor of
engineering at the Massachusetts Institute of
Technology (MIT). Professor of engineering at
MIT and author of *Flash! Seeing the Unseen by
Ultra-High-Speed Photography*, Harold Edgerton
revolutionized photography by inventing ways for
strobe lighting to be used as a common lighting
device. As a scientist and inventor at MIT, Edgerton,
known as 'Doc', worked not only with flash
lighting for still photography but was also a
pioneer in using stroboscopic lighting in motion
picture films and photography. Edgerton's
flash studies produced astonishing imagery of
flash-stop action of people and objects in motion:
golf clubs swinging, a child skipping rope, archer
and arrows, an acrobat flipping, a tennis racket
swinging forcefully through mid-air, a bullet
through a banana, water coming from a tap,
bursting balloons and droplets in milk. Edgerton
was the first photographer to utilize this flash
technology in sports stop-action photography,
making electronic, handheld flashes a common
photographic tool. With seemingly no end to
the uses for powerful surges of light, Edgerton
was then asked to help take photographs at
night from air force planes during the World
War II invasion of France. Coupled with radar,
the cameras and the strobes were timed to trigger
burst powerful amounts of light to create images
over enemy territory. It was the first time there
were images on film of enemy territory used for
US Army reconnaissance. High-powered bursts
of light being his specialty, Edgerton, known for
being a clever problem solver, also worked closely
with famed underwater explorer and scientist,
Jacques Cousteau, to create lighting to illuminate
the sea floor for photography and documentation.
Edgerton's photographs are revealing of a time
when photography was synonymous with science,
and although his photographs were taken as
studies of movement, they are eloquent and fluid,
his method and composition a visual sonnet. An
art form in themselves, each photograph reveals
lyrical movement broken into fragments within
one capture. Geometrics, science, photography,
composition and flash techniques all meld
together into a surreal yet academic conceptual
body of work. Edgerton died suddenly in January
of 1990 at the age of 86 in Massachusetts.

COMPOSITION

COMPOSITION
GLOSSARY

aspect ratio Describes the proportional relationship between width and height, either defined by the film or the sensor, or by cropping, where sides of the original are cropped so as not to be included in the final photograph. Common aspect ratios in photography include square, 3:2, 4:5 and 6:7.

balance How different elements in the frame are sized and positioned vis-à-vis one another.

deadpan A style of photographic portraiture where the subject shows no expression. While this style of portraiture has roots in painting, the German photographer, August Sander, is widely regarded as a major historical influence of this manner of photographic portrait. His massive tome of portraits, *People of the Twentieth Century*, are deadpan photographs showing the great variety of German people in the early half of the century.

emphasis The visual or thematic element in a photograph or artwork which is given particular focus by the artist. Techniques to provide visual emphasis on a specific subject include the use of contrasts and highlights, focus or depth of field, angle or point of view or uses of scale. Often a photographer can provide emphasis by simply centring the subject in the image, or employing techniques of grouping or continuation.

focal length The characteristic of a lens that determines what size objects will be rendered at a particular distance, and the angle of view. On a 35mm sensor, a 35mm lens will give a medium wide-angle view, whereas 300mm lens will bring objects closer, but have a more narrow angle of view.

golden spiral The idea of creating a circular sequence of elements within one frame. The compositional elements guide the viewer from the outside of the frame, in a spiral toward the centre of the frame. A golden spiral diminishes or grows by a factor of about 1.618 for every quarter turn it takes, the so-called golden ratio commonly found in nature.

harmony When the different elements within a photograph in terms of colour, size and placement play well together within the composition.

minimalism A style known for its precise and pared-down aesthetic. Minimalism advocates an essential quality of geometric abstraction, and often uses a monochromatic or a highly reduced array of colours. With influences from Zen philosophy and the Japanese sense of beauty, essential forms, order, materials and simplicity are advocated. Minimalism can be seen as a reaction against expressionism, ornamentation and even consumerism.

negative space The area between and around identifiable objects in a photograph. This space is sometimes considered empty, but when well used it can help to give more attention to the main object in the frame. The negative space is often a contrasting colour to the main subject, as this increases the visual impact.

order By structuring chaotic reality, a photograph can create organization and render that reality more accessible.

overlap When different elements partially cover one another within the frame and give the illusion of depth. Photographs of mountain ranges often use the idea of overlap to show their respective difference.

rhythm As in music, a photograph can have rhythm. This happens when a certain element appears several times in the same picture, with little or no variation. The viewer will then move with a certain ease (or rhythm) from one element to the next.

rule of thirds A classic idea of composition that states that an image can be divided into nine equal parts, by means of two horizontal lines and two vertical lines each placed at one third of the distance from the edge of the frame. When the main elements are placed at any of the four where these lines cross, the image will gain a more dynamic composition than when the main element is in the centre of the frame.

volume The space occupied by the main element in a photograph, and contrasted by the non-occupied space, the volume can suggest either the size or the spatial, three-dimensional aspects of the scene that is photographed.

VANTAGE POINT

the 30-second focus

Generally thought of as a

commanding or advantageous view in a situation, especially in a military manoeuvre. In photography, vantage point specifically describes the position (for example, looking through a window, from the bottom of a flight of stairs or on cliffs overlooking the ocean) from where a photograph was made, directly related to the physical point of view of the photographer. Certain scenes or subjects, depending on the setting, can often have multiple vantage points. As a result, for the photograph to express a certain vantage point creates understanding regarding the perspective of the photographer and the position of the camera, adding insight to the conditions under which the photograph was made. Vantage point can also be used as a fundamental tool for arranging background and foreground elements (along x, y and z planes), especially in a scene that contains a measure of elevation. Given the camera's function to compress a three-dimensional world onto a two-dimensional surface, the vantage point of the photographer can magnify or minimize certain details, create unique visual relationships within a scene or produce various distortions and effects.

3-SECOND FLASH
The physical position from where a photograph was made, creating a physical context for the photographer when making an image.

3-MINUTE EXPOSURE
Considering how the vantage point of a situation can construct many different viewpoints, a movie titled *Vantage Point* was released in 2008. In the movie, multiple witnesses recount their perspective of an event surrounding an assassination attempt on the US President, raising the possibility of competing truths in any given situation. This is clearly a reflection on the diverse perspectives, related to vantage point, which surrounded the assassination attempt of President John F. Kennedy.

RELATED TOPICS
See also
LANDSCAPE
page 40

NARRATIVE
page 44

PROXIMITY
page 16

SIZE
page 26

3-SECOND BIOGRAPHIES
GASPARD-FÉLIX TOURNACHON
1820–1910
Pioneer of aerial photography

30-SECOND TEXT
Ben Sloat

Brian Dilg, *Seed Pods and Winter Sky*

Finding a unique vantage point often means moving around, climbing up or crouching low, all the while keeping a keen eye on not only your subject, but also its (shifting) background.

FIGURE/GROUND
the 30-second focus

The world is chaos, and

photographers can help us create an order in that chaos. The relationship between the figures and their background is an important element in how the photograph is perceived by the viewer. The figure in a picture is often the most important element, as it indicates to the viewer the main subject. The ground is there to provide context to that main subject. If there are visually too many main subjects, or the positioning of the figure on the ground is visually not clear, the viewer will have a hard time understanding the photograph. Contrasting colours, for example a black dog in a white snow landscape, will help the viewer to identify the figure, the main subject of the photograph, and distinguish it from its background. It is also important for the visual pleasure of the viewer to create a relationship between the figure and its background. If the background provides the context of how the figure is understood, then the relationship between the two should be visually clear. Most people understand this basic principle when they take a picture of the Leaning Tower of Pisa: they place themselves in such a position that they look like they are pushing the tower over by themselves.

RELATED TOPICS
See also
FRAME
page 14

JUXTAPOSITION
page 80

VANTAGE POINT
page 74

3-SECOND FLASH
The figure/ground principle is how the figure or figures in a photograph are placed in the background, and how they relate to one another.

3-MINUTE EXPOSURE
As in all visual arts, photographers play with perception, and one such way is to use the principle of figure to ground. In these photographs the viewer is confronted with another point of view in which the distinction between the figures and the background is not clear, and the depiction becomes one of a different object.

30-SECOND TEXT
Marc Prüst

Erik Kessels, *In Almost Every Picture #9*

In this collection of found photography, Erik Kessels presents the inability of a couple to capture their black dog in a variety of everyday situations. It's precisely what most photographers will try to avoid, but the consistent failure to properly expose the dog gradually becomes a figure-ground relationship itself.

LINES

the 30-second focus

Talented photographers can

see just the right light, the right combination of events and just the right composition to create a visual feast. Using lines as a compositional element, photographers can bring movement, emotion, dimension and depth to a photo. Beginning with the lines inherent to every photograph, the four sides of the frame, they can compose dynamic imagery using the lines found in nature. Perhaps because of the way our inner ear usually keeps us standing upright, horizontal and vertical lines are our norm: trees, buildings, the horizon. In photos, they create visual stability. On the other hand, diagonal lines are energetic and disquieting; the eye tends to move along them seeking a more restful landing place. Skilful photographers use lines to immediately grab the attention of the viewer and draw them into a photograph. Lines communicate concepts and emotions without being obvious. Angular lines, circular lines, repetitive lines and converging lines are all visually appealing. Lines found at horizons, on the street, along a sea break, across the sky and through the trees can segment an image, and compartmentalize messages within a picture. Used wisely, lines draw the eye to the action and accentuate the narrative.

3-SECOND FLASH
Becoming aware of how lines flow through the composition of a photograph can add an emotional, evocative level to photographs.

3-MINUTE EXPOSURE
Placing lines strategically within the frame is a visual tool often used in photography. Using lines deliberately gives visual depth to a photograph by leading the eye around the frame. Lines are an excellent way to viscerally engage the viewer. Coupled with perspective and content, narratives can be comprised of simple elements, but have bigger impact with leading lines.

RELATED TOPICS
See also
ATTENTION
page 122

HUMAN PERCEPTUAL SYSTEM
page 118

3-SECOND BIOGRAPHIES
EDWARD WESTON
1886–1958
Founder of the photographic group ƒ/64, best known for his still-life photographs and nudes. Both were explorations into the organic contours of nature.

30-SECOND TEXT
Jackie Neale

Kirsanov Yury,
Geometry of Architecture

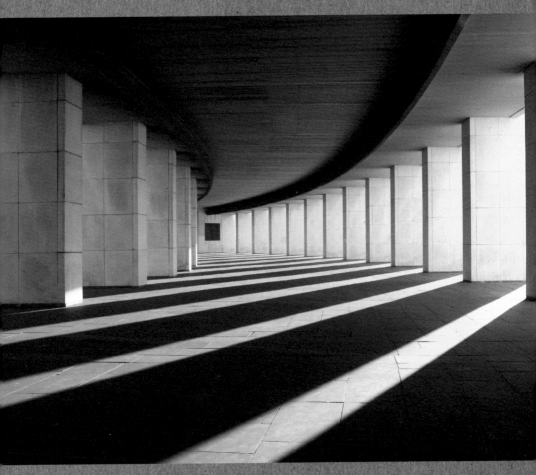

Strong verticals repeat on either side of the frame and stretch back to an unseen vanishing point, bold diagonals exploit high-contrast lighting to connect the opposing verticals and all the while a subtle, low-contrast curve complements the rigidity of the lines below. It's possible to describe some scenes purely in geometric terms.

JUXTAPOSITION

the 30-second focus

3-SECOND FLASH

Juxtaposition is a compositional technique that highlights differences and invites critical comparison by placing two contrasting elements next to each other.

3-MINUTE EXPOSURE

Juxtaposition has long been a tool used by the great masters of photography. Walker Evans incorporated found text in the landscape into his images. Henri Cartier-Bresson's repeating shapes would draw the viewer deeper into his narrative. Elliott Erwitt is a master of the visual pun. These photographers focus on framing contrasting or similar elements in a scene, enabling them to create impressive visual commentaries about their society.

Juxtaposition is a compositional

technique that places two elements with a strong difference of some kind – for example, weight, tone, colour, gesture, mood size – next to each other. This may be achieved within an image itself, but also through the placement of an image in a specific location, frame or text that is either similar or contrasting. It often articulates irony and humour, particularly in street photography. It is a way of inviting the viewer to contemplate a specific idea by comparing and contrasting subjects. Juxtaposition gives the photographer a visual means to create tension, depth, interest and meaning. It can be created by putting two opposite subjects together to provoke intrigue, or using contrasting colours like warm and cool to create a sense of tension. Slow shutter speeds that capture moving objects against a still background create a sense of urgency, while isolating a subject with depth of field may draw the viewer's attention. Simply choosing unique angles to shoot from is another method to create interesting comparisons. Juxtaposition is a key compositional tool to inform viewers about the relationship between things, be it their similarity or difference.

RELATED TOPICS

See also
COLOUR OF LIGHT
page 106

CONTEXT
page 124

MEANING
page 116

TIME
page 18

3-SECOND BIOGRAPHIES

ROBERT FRANK
1924–
Swiss photographer known for his work, *The Americans* – an outsider's view of mid-century American society

30-SECOND TEXT
Adiva Koenigsberg

Margaret Bourke-White,
World's Highest Standard of Living, 1937

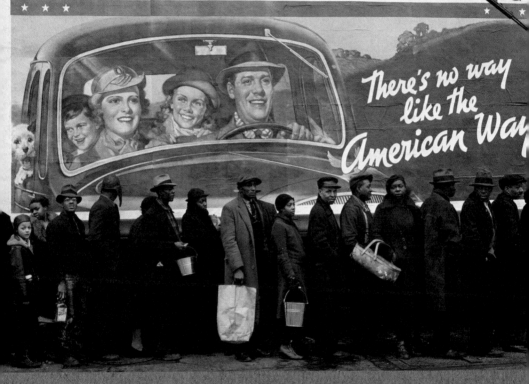

WORLD'S HIGHEST STANDARD OF LIVING

There's no way like the American Way

When antithetical elements combine in stark relief, that juxtaposition can provoke a cynical reaction – such as this line of Kentucky flood victims serving as a physical refutation of the ideal presented in the poster above them.

MOTIF

the 30-second focus

In an artistic sense, motif can be considered in many ways. Physical patterns that are repeated create a sense of rhythm that is often visually pleasing, as the human brain seeks patterns involuntarily in order to make sense of scenes. This type of motif is most commonly found in nature, fashion and still life photography where natural or human made pattern and repetition is a frequent subject. Often certain cultures, locales or historical movements have specific motifs that define them. Motifs can also be a recurrent subject matter found over a larger body of work, used as a form of visual iconography. The icon of the Weimaraner dog, for example, is a motif used repeatedly in William Wegman's photography. Another form of motif is its use as a physical metaphor or explicit narrative element. The motif is always a recognized visual form, one that can create a theme or mood, but is always rooted in the physical world. The recurrent images of cars in Robert Frank's 1958 book, *The Americans*, for example, was a motif implying aspects of motion, travel, freedom, desire and change during a period of massive social and cultural transitions in America.

RELATED TOPICS
See also
LANDSCAPE
page 40

NARRATIVE
page 44

REPRESENTATION
page 20

VERNACULAR
page 36

3-SECOND BIOGRAPHIES
CINDY SHERMAN
1954–
American photographer
whose work studies the
representation of women and
role of feminine stereotypes
in modern visual culture

WILLIAM WEGMAN
1943–
Photographer using
canine motifs

30-SECOND TEXT
Ben Sloat

Brian Dilg, *Alpha Dog*

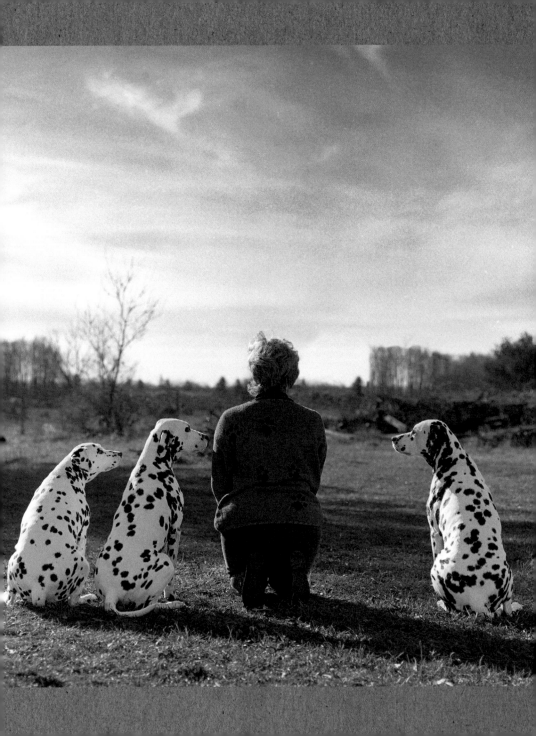

EMERGENCE

the 30-second focus

We live in an age where

everything is photographed and shared. Instantly. Globally. Without restraint. So it's not too surprising when photographers wishing to rise above the fray succumb to the temptation to inflate attention-getting devices until every aspect of an image screams for attention, or to get consumed by making beautiful surfaces, while neglecting to provide substantive content. The result is visual exhaustion or quick disinterest, however impressive an image may be at first glance. In contrast to that is an approach based on subtlety, restraint and rich content. Viewers are intelligent and our brains enjoy decoding images. Rather than simply emphasizing visual impact or providing one obvious interpretation, photographs can provoke interesting questions, imply relationships or cause and effect, and delay both visual perception of key details and realization of a picture's full meaning. Deprived of an obvious punchline, each viewer will assign a unique explanation to the image. The image grows with the mind of the viewer. This approach makes the viewer an active participant who co-creates the ultimate meaning of a photograph. It might be argued that smart photos employ the most powerful tool of all – the unique imagination of each viewer.

3-SECOND FLASH
Images that reward close attention utilize subtlety to delay the viewer's complete realization of the full story implied by the elements of a photograph.

3-MINUTE EXPOSURE
Emergence is based on the way we 'read' pictures. Obvious connections are underplayed, leaving room for viewers to assign unique meanings. Our brains seem to re-experience these realizations afresh even after many viewings: man with leaf blower... wall... hedge... spotless parking lot... back to the man and his purposeful march, face and leaf gun pointed straight at that hedge. Heaven help the poor leaf hiding over there – or is the hedge the next victim?

RELATED TOPICS
See also
HUMAN PERCEPTUAL SYSTEM
page 118

SURPRISE
page 120

3-SECOND BIOGRAPHIES
NILS JORGENSEN
1958–
Danish street photographer and photojournalist working in the UK, known for his dry visual wit

30-SECOND TEXT
Brian Dilg

Lorrie McClanahan,
Untitled

While photographs do indeed put all their cards on the table, so to speak, that does not mean they can always be read instantaneously. The process of visually decoding the meaning of a photograph can be part of the composition itself – particularly when the subject does not explicitly explain or justify itself.

SUBSTITUTION

the 30-second focus

3-SECOND FLASH
To replace a certain element in a frame by something that's in front of or next to it, but is perceived as being on the same plane due to the flat surface of the photograph.

3-MINUTE EXPOSURE
Substitution is often found in amateur pictures, where the photographer didn't realize this change from a spatial reality to a flat picture. Arms become a huge cleavage, potted plants become someone's hair. Instead of mistaken pictures, these images sometimes become viral internet sensations.

A photograph is a flat or 2D representation of a spatial or 3D reality. Usually photographers aim to suggest that space within their frame by using strong diagonals or a perspective view. But, this feature can also be used very effectively to create or suggest a different reality. Because you cannot see depth in a picture, you can substitute, for example, a human's face for a dog's, or suggest a run-down face by placing it behind a rained-on window. If a face, for example, is replaced within the frame by something else, something that might resemble a face, our brain experiences a small jolt. There is a moment of surprise or shock: something is not quite right. This continues even if we understand on second viewing how the image is constructed: there is something in front of the guy, blocking his face. But the image has already caught our attention. Either funny or with a more serious undertone, this technique can be used to play with reality. Sometimes the result is a serious picture that makes a powerful statement; more often, though, the result is a humourous photograph.

RELATED TOPICS
See also
FRAME
page 14

HUMAN PERCEPTUAL SYSTEM
page 118

SURPRISE
page 120

3-SECOND BIOGRAPHIES
ELLIOTT ERWITT
1928–
French-American documentary and advertising photographer, famous for his impeccable sense of visual wit, and ability to capture the absurd in the everyday

30-SECOND TEXT
Marc Prüst

Harris Panagiotakopoulos, *Eva, 2013*

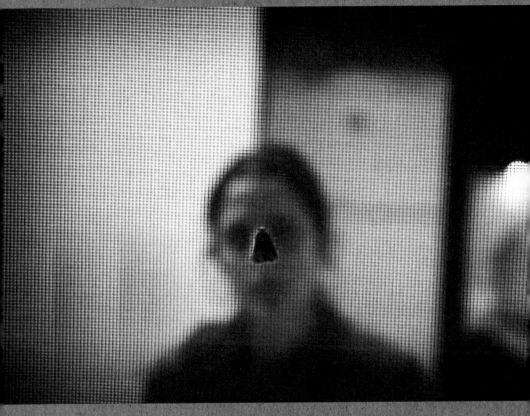

It requires a keen eye for composition and quick reflexes to capitalize on spontaneous substitutions as their potential arises, and the result is often presented as a visual puzzle – an impossible situation that the viewer must deconstruct in order to understand how the moment came to be.

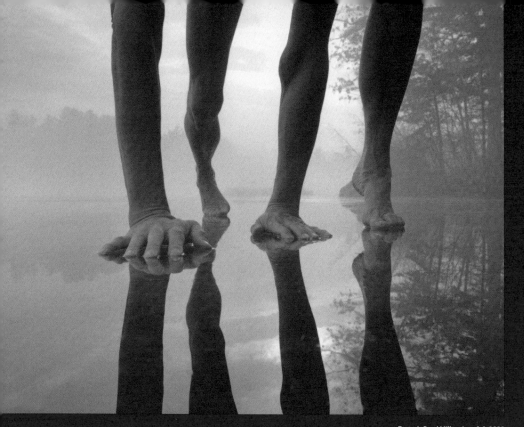

Foster's Pond Millennium, 1.1.2000

1945
Born in Helsinki, Finland

1951
Emigrates to the
United States

1967
Returns to Finland
for the first time
since emigrating

1970
Begins taking self-
portraits while working
as an advertising
copywriter. Studied at
Apeiron Photographic
Workshops with
John Benson

1974
Graduates the Rhode
Island School of Design
(RISD) with an MFA in
photography, studying
with Harry Callahan and
Aaron Siskind

1978
First monograph
Frostbite published

1987
Joins faculty of
the University of
Massachusetts Lowell
as Professor of Art

1991
National Endowment
for the Arts Regional
Fellowship

1992
Conferred the First Class
Medal of the Lion by the
Finnish Government

1994
Monograph *Waterline*
published. Winner of
the 25th Rencontres
d'Arles Book Prize

1999
Monograph *Body Land*
published

ARNO RAFAEL MINKKINEN

Minkkinen is a Finnish-American photographer who has been making environmental self-portraits for over 40 years. His work features his own body, mostly in outdoor settings and always nude, often impersonating the forms around him. His own figure merges and disappears into the landscape in ways that are sometimes surreal. His un-manipulated images utilize vantage point and deep focus to distort scale, to mimic and merge with trees, water and rocks, and a monochrome palette to minimize differences between his body and the landscape. The physical difficulty and risk necessary to achieve his images raises the question not just of how, but why.

Eventually we may notice that his face rarely appears. Sometimes he adds a second figure to the composition, often including a young, beautiful female face directly in front of his own. Minkkinen has written that his mother was disappointed that the baby she brought into the world was not the beautiful daughter of her dreams, but rather a boy born with a cleft palate. Viewing his singular images through this history, new resonance is given to the way in which his own lanky form is made extraordinary and magical by an eye willing to look at him afresh, his own lens.

2005
Monograph *SAGA: The Journey of Arno Rafael Minkkinen, 35 Years of Photographs* published

2008
Monograph *Homework: The Finnish Photographs* published

2009
Monograph *Swimming in the Air* published

2010
Monograph *Balanced Equation* published

2013
Receives Lucie Award for Outstanding Achievement in Fine Art

2013
Screens *The Rain House*, a feature film he wrote and directed

2013
Demo screening of *Facing Beauty*, a feature film under development, at New York's Lincoln Center

LIGHT & LIGHTING

diffusion The scattering of light, which otherwise travels in a straight line, into myriad different directions. Each beam continues to cast a shadow, but the many shadows are all in slightly different positions. Soft light results, with its shadow being a gradual transition rather than a distinct line. Accomplished by passing light through translucent material (or atmospheric particulate like smoke, fog, clouds or rain), or bouncing it off of a matt surface.

catchlight The reflection of light sources in the human eye. Catchlights indicate the direction from which the light is coming, and help give eyes a sense of life. The size of the catchlight has a particularly dramatic impact, but large catchlights require very large sources, or sources placed extremely close to the face. Reflectors or additional sources are sometimes used just to create catchlights in portraiture.

edge light Also known as a rim light, it is angled from the back side of a subject and at a slight horizontal angle from where the camera is placed, typically just grazing one side of the subject with light. Its purpose is to clearly delineate the edge between the foreground subject and the background. A light that is precisely behind the subject relative to camera is known as a back light.

falloff Like all signals, light dissipates over distance, weakening as it travels. The change is most dramatic near to the source, and is known as falloff. Since the rate of dissipation is exponential rather than linear (where brightness equals the inverse square of the distance), the closer a light source is to a subject, the more obvious the falloff and the more impossible it is to light the subject evenly. The sun is so far away relative to the size of the earth that there is negligible falloff across the lit surface, which is one of the reasons electric lights look so different from sunlight.

fill light A secondary source angled to fill in the shadows created by the key and edge lights. Since it is usually soft (diffused), much less bright than the key and edge lights, and typically casts no detectable shadows, it is hard to sense as an additional light source. It is used (or omitted) to control contrast on a subject.

hard light A direct source of light, not diffused. The sun is the hard light with which everyone is most familiar, but our experience of it is always somewhat diffused through the atmosphere surrounding the earth. The degree of diffusion changes dramatically with weather conditions. Hard light creates harsh contrast and crisp, hard-edged shadows.

key light A term from the theory of three-point lighting referring to the main light source in a scene, usually the brightest element, most commonly on the same side of the imaginary line drawn through the subject perpendicular to the camera.

magic hour Sunrise and sunset, the time when the sun is closest to the horizon, the rays becoming much warmer in colour than normal because we are viewing them through the more dense atmospheric particulate closest to the surface of the earth, and the cool blue of the sky makes a startling juxtaposition against the warm sunlight. White clouds also act as reflectors and pick up a wide range of dramatic colours as they receive the last or first rays of sunlight.

reflector Any surface that reflects at least some light. Professional reflectors can be made from fabric over a plastic or metal frame, and come in a variety of surfaces, most commonly matt white (creating a soft source), hard silver or gold (a mirror-like surface). Used to control contrast in professional lighting applications. Foam core and cardboard sheets are also used. Metal-lined reflectors, vaguely cylinder shaped, also snap over strobe lights to make them more directional.

snoot A simple tool to make a light more directional by passing it through a long black cone that absorbs light that would otherwise by widely dispersed. Comes in various sizes for different angles of dispersion.

softbox A professional lighting diffuser, shaped like a rectangle, octagon or a 16-sided box, with a variety of translucent diffusers at the widest end and an opening for a light at the small end. Made of fabric, sometimes lined with metallic material for extra reflectivity or heat protection when used with hot lights, and held rigid by thin metal struts that can be removed to collapse the unit into a very compact bundle for transportation. They come in a variety of sizes; the larger the size, the softer the light. Usually velcro lines the large end to support attaching egg crates for a more narrowly focused source.

soft light A light source that has been diffused. Common tools for its creation include softboxes or umbrellas with translucent material, gels and reflectors.

HIGHLIGHTS & SHADOWS

the 30-second focus

Highlights generally refer to

the most brightly illuminated areas of a scene, while shadows refer to the darkest areas. The brightest highlights, called specular highlights, are created by angling a surface to reflect the light source itself into a lens. Shadows are cast by obstacles that block light from striking a surface. These properties of light convey the three-dimensional contours of objects to our brains. Cameras cannot see detail in scenes with as much contrast as our miraculous, dynamically compensating eyes. To cameras, dark shadows go pure black, and the brightest highlights turn pure white, and both lose all detail, whereas the human eye adapts dynamically to whatever it looks directly at. On the other hand, photographers can add contrast to scenes that look 'flat', even to our eyes. Thus, a major creative component of photography is the art of compressing or expanding the tonal range of a scene to suit the limitations of the photographic medium. In high-contrast situations, either shadow or highlight detail must be sacrificed. This shouldn't be regarded only as a drawback, although it is a challenge. The contrast added by the process is one of the reasons we find photos so compelling.

RELATED TOPICS
See also
EXPOSURE
page 58

TONAL ADJUSTMENTS
page 142

3-SECOND FLASH
While cameras have limitations in high-contrast situations, photographers are also able to manipulate tones to create impressions that would otherwise be invisible.

3-MINUTE EXPOSURE
The closer a camera is positioned at the same angle as a light, the more shadows disappear behind the subject, and the more two-dimensional a subject appears. This is not necessarily bad: front light is a classic technique for de-emphasizing imperfections in a subject's skin and making it appear smooth and flawless. How a photographer uses light and the tonal palette (range of tones from darkest to lightest) is a hallmark of personal style.

3-SECOND BIOGRAPHIES
MICHAEL KENNA
1953–
English fine-art photographer, known for his masterfully orchestrated B&W tonal palette

JUERGEN TELLER
1964–
German fashion and fine-art photographer, known for his unusual use of on-camera flash

30-SECOND TEXT
Brian Dilg

Trent Parke, *from* Dream/Life series, *Australia, Sydney, 2001*

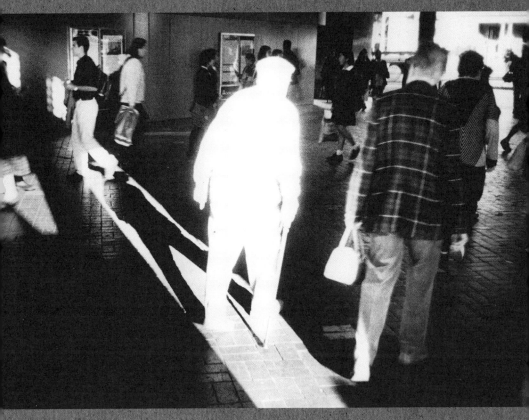

An elderly man dressed in white walks into harsh sunlight in a tunnel under Circular Quay railway station. It is precisely because the human eye would never render this scene in this way, that makes this image is so engaging.

THREE-POINT LIGHTING

the 30-second focus

Three-point lighting is a

technique used to give depth to an image. Through the use of highlights and shadows, photographers convey three-dimensional properties within two-dimensional images. In studio settings, specialized electric lights (continuous or strobe) are used, while outdoors the sun is the primary source of illumination. All light has a direction and helps create the mood of the image. In three-point lighting schemes, each instrument is named by its function and position with relation to the subject. The key light is the primary source of illumination. Its colour, angle, quality (soft or hard) and strength determine the overall concept and mood of the lighting design. Fill light shines from a complementary angle to the key light, is usually soft (diffused) and always less intense than the key light. It is not infrequently just a bright surface reflecting the key light. Its role is to partially illuminate shadows created by the key light. The backlight or rim light comes from roughly behind the subject (relative to the camera) and separates the subject from the background. Varying the position of and ratios between these three sources is the basis of any lighting scheme.

3-SECOND FLASH
A traditional and simple arrangement of lights that, due to their directionality, adds depth and dimension to an image.

3-MINUTE EXPOSURE
Traditional three-point lighting usually puts the key light at 45 degrees to one side of the subject and about 45 degrees above it. However, experimenting with the placement of the key light is an easy way to vary mood. Top light will create a sinister looking subject, with deep eye-socket shadow. Front light will disguise unwanted facial marks. Up-light, placed below the subject, will create unusual, unnerving shadows. A back light used alone will create silhouettes.

RELATED TOPICS
See also
DIRECTION OF LIGHT
page 104

3-SECOND BIOGRAPHIES
YOUSUF KARSH
1908–2002
Armenian-Canadian
portrait photographer

30-SECOND TEXT
Adiva Koenigsberg

From this basic arrangement, a huge variety of lighting styles can be derived by modifying any of the lights to a harder or softer type, by changing the intensity of each source or by adjusting the position of the subject relative to the lights.

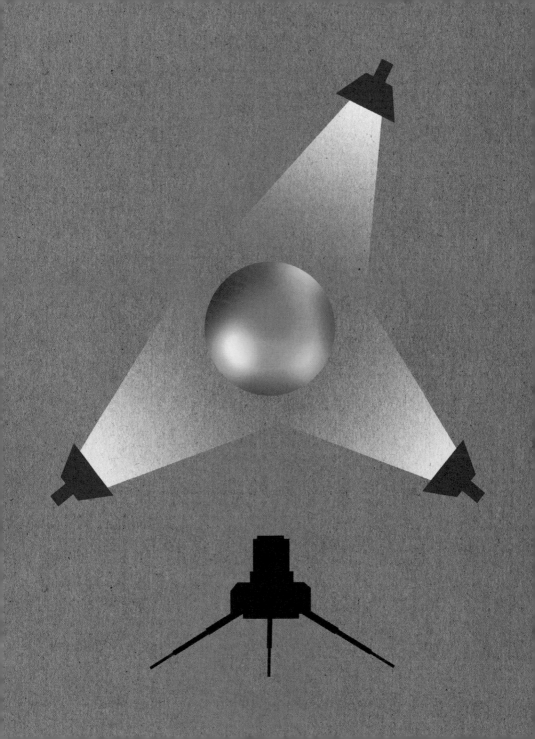

QUALITY OF LIGHT
the 30-second focus

'Quality' of light refers to its

direction, intensity, diffuse or direct nature and colour. We experience natural light mostly from over our heads – sunlight, starlight and moonlight. We are highly sensitive to the intensity of the sun and its absence at night. Artificial light sources are much closer to us than the sun, so the way that light wanes over distance is seen more acutely. 'Hard' light comes from a single source and travels in a straight line. It creates sharply defined shadows and high contrast. 'Soft light' is diffused and multi-directional. It creates soft-edged shadows and low contrast. Diffusion is caused by atmosphere, by reflecting from a matt surface or synthetically by placing a translucent material between a source and the subject (a 'diffuser'). Daylight is profoundly affected by atmospheric conditions and the angle from which we perceive it, and varies widely. Much of it is trapped by the atmosphere and scattered as cool blue skylight. Sunlight viewed at 'magic hour' (sunrise or sunset) is seen at an acute angle to the curvature of the earth, and passes through the more dense atmosphere found there, dramatically warming its colour. Collectively these qualities create the ineffable effect that light has on us.

3-SECOND FLASH
Not all light is created equal, and even once created, can be modified by a number of factors.

3-MINUTE EXPOSURE
All daylight is created by the sun. However, there are three main components illuminating a subject: light directly from the sun, light diffused or reflected by atmospheric elements and light reflected off of the earth or objects on it. The atmosphere acts as nature's filter: dust, haze, fog, clouds and pollution scatter and soften the light. A sunlit sky will appear blue because of atmosphere that scatters shorter-wavelength light more than longer wavelengths.

RELATED TOPICS
See also
COLOUR OF LIGHT
page 106

MEANING
page 116

3-SECOND BIOGRAPHIES
ARTHUR FELLIG (WEEGEE)
1899–1968
Photographer and photojournliast, known for his stark black-and-white street and crime-scene photography made with a flash

MARTIN PARR
1952–
British documentary photographer, member of Magnum agency, known for shooting with an unusual ring flash on his lens

30-SECOND TEXT
Adiva Koenigsberg

Arthur Fellig, *Murder on the Roof, New York, 1941*

The dissonance in viewing such a grim scene rendered in such bright, hard light is the trademark of Weegee's visual style.

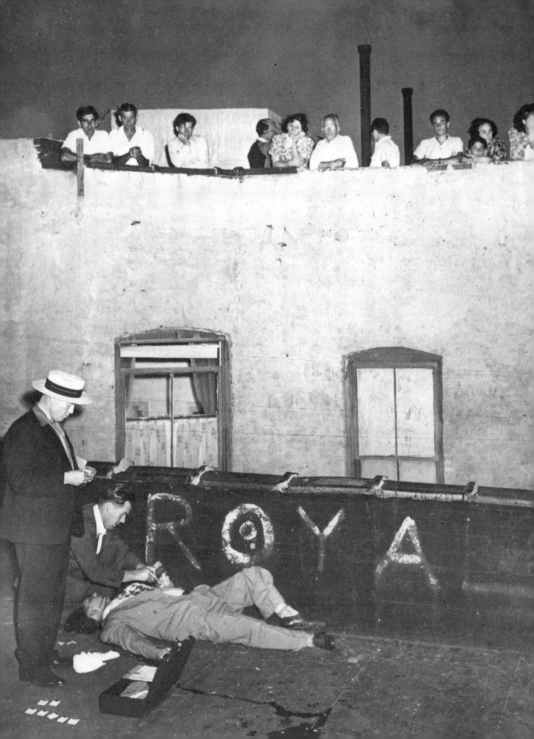

DAYLIGHT

the 30-second focus

3-SECOND FLASH
The quality and colour of daylight varies wildly as atmospheric conditions affect the ratio, colour and quality of direct sunlight and skylight.

3-MINUTE EXPOSURE
Direct sunlight is 'hard'. Skylight is 'soft', meaning it reaches us from millions of rays, each deflected off of particulate comprising the atmosphere at different angles. Direct sunlight casts a hard-edged shadow. Soft skylight casts soft-edged, nearly invisible shadows that are actually millions of shadows in slightly different positions merging together, nearly negating each other.

What could possibly be surprising about something we experience everyday of our lives? Well, surprisingly enough, daylight is an extraordinarily complex phenomenon. We orbit around a single light source, our sun. Some of that light reaches us directly. So much of it gets trapped by the atmosphere around the earth that we effectively have a second light source, skylight. Objects in the shade are illuminated by skylight (which is much more blue than direct sunlight), and by rays of light reflecting off of countless surfaces. Daylight is at its most dramatic when the sun is near the horizon. Rays of light create intense, warm colours as they pass through the thick atmosphere closest to the planet's surface from our viewing perspective. Clouds reflect the last rays of the sun in intense, quickly shifting colours even as dusk settles on the surface of the earth, forming dramatic juxtapositions of cool skylight and warm sunlight. Daylight is never white, although we are not good at seeing it. It changes radically depending on atmospheric conditions, the angle from which we view the sun, our position on the planet and how the landscape around us reflects and diffuses it.

RELATED TOPICS
See also
QUALITY OF LIGHT
page 98

COLOUR CORRECTION
page 140

3-SECOND BIOGRAPHIES
STEVE MCCURRY
1899–1968
Documentary photographer known for his exceptional attention to colour palette

30-SECOND TEXT
Brian Dilg

Brian Dilg, *Sunset in Ice*

Two tones of daylight are here captured together in a single image by means of an unusual vantage point. The setting sun is brilliant and warm, while the shadowed surface surrounding the puddle is blue – an effect enhanced further by the physical presence of cold ice.

ARTIFICIAL LIGHT

the 30-second focus

Artificial light is anything that

is not a natural light source: the sun, the moon and fire, for example. This includes indoor lamps, fluorescent lights, strobe lights, HMI lights, street lights and LED lights. In professional photography, strobe lighting, LEDs, 'hot' (continuous) HMI, tungsten or fluorescent sources are often used to light in a systematic, controlled way. However, most photojournalists or candid photographers simply use the ambient light available when indoors. This type of artificial light is limiting, but with a modern digital camera's ability to shoot at high sensitivity, artificial light provides enough illumination of a scene without disturbing the mood by using additional lighting. Artificial lights have an enormous variety of colour temperatures: cool blue strobes or LEDs to extremely orange sodium vapour street lights. Although an automatic white-balance feature on a digital camera does an excellent job at averaging the colour temperatures of mixed artificial light sources, when these sources are combined in a single image, no single white balance setting can render all sources as white, requiring further colour correction once a Raw file is processed. Unless marked tungsten (3200K), all film is colour balanced for 5500K – the 'daylight' standard.

3-SECOND FLASH
Practical indoor lights intended as illumination can be used as-is to preserve the authenticity of a scene, or additional professional lights can be used for finer control.

3-MINUTE EXPOSURE
Practical indoor lights, set lights and flash are used when a photographer needs to control their lighting. Anything from a single light source to an elaborate studio lighting setup are artificial light options. Keeping in mind the needs of the photograph, artificial light maximizes the quality of the shot by lowering the ISO and allowing a smaller aperture. Artificial light can be mixed with ambient light to create a natural or dramatic lighting effect outdoors.

RELATED TOPICS
See also
COLOUR CORRECTION
page 140

COLOUR OF LIGHT
page 106

STROBE LIGHTING
page 62

3-SECOND BIOGRAPHIES
NAN GOLDIN
1953–
Most known for documentary photos of her friends in the 70s, all lit in artificial indoor lighting. Goldin used existing artificial lighting rather than strobes, and one can see the variations in colour temperature used to create a mood that was a consistent thread of authenticity throughout her work

30-SECOND TEXT
Jackie Neale

Brian Dilg, *Regard*

The high precision of studio lights permits very delicate and deliberate effects, like the edge lighting just along the subject's cheekbone.

DIRECTION OF LIGHT

the 30-second focus

3-SECOND FLASH
The direction of a light
conveys place, time of
day, environment, the
nature of the source
and most fundamentally,
casts shadows on the
opposite side.

3-MINUTE EXPOSURE
The angle of a light source
relative to our vantage point
(or a camera's) determines
what is revealed to us by
light and what is concealed
by shadows. Direction is
one of the primary qualities
that gives light its specificity
and character. Skilful
photographers position
lights to cast interesting
shadows, to create mood,
to mimic time and place as
lit by the sun, and to create
surreal or unfamiliar
environments.

Nearly all of our experience of
light on earth is of a sun above our heads. Light
from below is such an anomaly that it disorients
our brain's fundamental sense of how things
are supposed to look. Horror movies regularly
exploit this by placing lights below the eye level
of a character we are meant to fear. The height of
the sun is one of the most telling elements that
gives a photo its geography and time of day. The
low path the sun travels through the sky is as
telling of winter as its harsh overhead path is to
summer. Photographers mimic our experience
of electric light sources: theatre lighting tends
to live mostly in the ceiling, and is projected
in long, narrow beams. Lamps in residential
settings are often at table level. Commercial
buildings are commonly lit with overhead
fluorescent banks. Snow is a big, soft reflector
at our feet; water is too, but always moving
and sparkling. For a short time at the beginning
and end of the day, the sun rakes dramatically
across the ground at an angle so low that it
dips below eye level at its most extreme.

RELATED TOPICS
See also
DAYLIGHT
page 100

QUALITY OF LIGHT
page 98

ARTIFICIAL LIGHT
page 102

3-SECOND BIOGRAPHIES
DAN WINTERS
1953–
Commercial photographer known
for his precise, creative portrait
lighting

30-SECOND TEXT
Brian Dilg

Brian Dilg, *Cell Phone, 2nd
Avenue, New York*

*Shooting away from
the sun lets you capture
the shadow form of
subjects as they stretch
away from the camera,
but you also have to be
careful not to capture
your own shadow in
your shot – unless
that's an intended part
of the composition.*

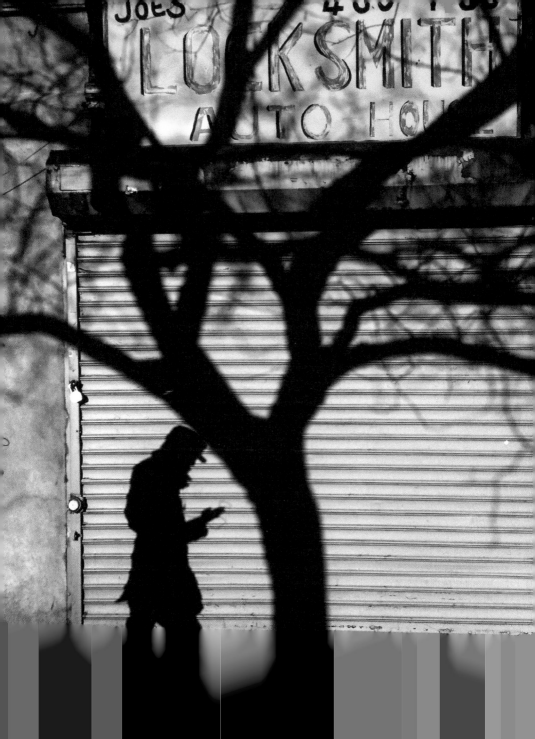

COLOUR OF LIGHT

the 30-second focus

3-SECOND FLASH
The colour of light is determined by which wavelength is reflected back to our eyes.

3-MINUTE EXPOSURE
Human eyes automatically adjust to the colour of light; cameras don't. When shooting film, colour filters are used in order to match the colour of a light source to the white point of the film (colour temperature) so the light will appear white. A neutral (18%) grey card is a useful tool for achieving correct colour (white balance) in digital photography, as it can be used by the camera to measure the colour of a light and add its opposite to render it as white.

Light is a form of energy, specifically electromagnetic radiation whose wavelength is between 400 and 700nm (nanometres). Four-hundred nanometres corresponds to the colour violet at the shorter wavelength of the visible spectrum, and 700nm to red, the longest visible wavelength. Digital imaging commonly uses three primary colours of light: red, green and blue. Mixing equal amounts of these three colours, called an additive colour system, creates white light. Mixing equal proportions of any colour with its opposite also creates white, as will mixing any three equidistant colours in equal proportion. The colour pairs red/cyan, green/magenta and blue/yellow are called complementary colours; they are exact opposites. Adding equal amounts of any pair of complementary colours produces a shade of grey. Colour is described as a combination of hue, saturation and luminance. Hue is the appearance of a colour (described by its common name, like yellow) determined by the wavelength. Saturation is the purity of the colour, or how far it is from a colourless shade of grey. Luminance is how bright the colour is. Contrast is created by a difference in luminance and/or colour.

RELATED TOPICS
See also
ARTIFICIAL LIGHT
page 102

COLOUR CORRECTION
page 140

DAYLIGHT
page 100

3-SECOND BIOGRAPHIES
ISAAC NEWTON
1642–1727
English physicist and mathematician who observed that a prism splits white light into all of the colours of the visible spectrum

30-SECOND TEXT
Adiva Koenigsberg

The human eye is most sensitive to the colour green, which is why there are twice as many green photo receptors in digital imaging sensors as there are red and blue ones. This amorphous blob of colour is, in fact, an extremely precise representation of the range of colour visible by the human eye. It's called the CIE 1931 Color Space Chromaticity diagram. The axes are measured in wavelengths (nm), and represent chromaticity and luminance values.

This is not, in fact, an accurate representation of the true diagram – it's impossible to print it, even high-quality paper coupled with professional printing techniques falls short of the full range of colours your eye is capable of seeing. The same is true for the colours that your camera can capture. These colour gamuts take the form of triangles within this graph, of various sizes depending on the device in question, but always falling entirely within the CIE 1931 Color Space shown above.

Eddie Anderson, 21 years old, Houston, Texas, $20, 1990–92

1951
Born in Hartford, Connecticut, United States

1976
Post-Graduate Certificate, School of the Museum of Fine Arts, Boston

1979
MFA, Yale University, New Haven, Connecticut, United States

1980
First National Endowment of the Arts fellowship (repeated 1986 and 1989)

1987
Awarded Guggenheim Fellowship

1990–1992
Used National Endowment (NEA) of the Arts grant to shoot *Hustlers* series in Los Angeles

1993
Strangers first museum solo exhibition at Museum of Modern Art, New York

2001
Heads exhibition premiers. Receives Infinity Award for Applied Photography, International Center for Photography, New York

2006
Lucky 13 exhibition premiers

2011
Eleven exhibition premiers, showcasing large-scale editorial portfolio, commissioned by *W* magazine

PHILIP-LORCA DICORCIA

'Photography is a foreign
language everyone thinks
he speaks'

Philip-Lorca diCorcia

To look at diCorcia's work is to experience the human theory of mind: we cannot help but imagine what others are thinking, but our imagination will forever outstrip our knowledge. As tempting as it might be to project a pleasant fantasy onto someone we do not know, what we are really seeing is ourselves. DiCorcia has both staged subjects and chosen moments created by people unaware of the camera, but in which they seem to have miraculously organized themselves into a single story. He brings a film director's attention to character, creating a sense of story, but the precise narrative is kept tantalizingly uncertain. At the heart of his work are questions about presumptions of truth in photography. His work resists definitive meanings by mixing the signifiers of documentary work with the dramatic lighting of narrative cinema. He confounds photography's cherished notion of a decisive moment by capturing singularly indecisive, even banal moments.

In 1990–92 he used an NEA grant to photograph young male hustlers in dramatically lit tableaux against the underbelly of Hollywood. Titling the series *Hustlers*, he captioned the images with their names (often obviously not their given names), birthplace, age and the fee they requested (paid with his NEA funds). Since then, he has sometimes worked at even greater distances from his subjects, hiding strobes on city streets and photographing passing strangers – a process that gives, in his words, 'a cinematic gloss to a commonplace event'.

The arguments over how to classify his images have been passionate. Many of them are made on the street, but they don't look like other street photography. They could be called documentary, but diCorcia is either staging or picking and pre-lighting each location and waiting for unwitting one-time participants to match an archetype of his own interest. The theatricality of the images strongly suggests some kind of narrative, but no specifics are given; the viewer must assign their own stories. One of the most interesting issues raised by his work is the way in which we stubbornly expect photography to convey a kind of veracity, even when it draws attention to its own artifice. By comparison, the overt desire of narrative cinema to manipulate our emotions through score, editing and acting. are perhaps too prominent for us to ever forget that we are being tricked.

DiCorcia has served as a visiting teacher and critic at Yale University since 1996.

PHOTOGRAPHIC THEORY

PHOTOGRAPHIC THEORY
GLOSSARY

abstraction In theoretical terms, an abstraction can have several meanings. One is of a universal concept that has no physical form such as love or faith; another can be a subjective term which is constantly shifting, such as the symbolism which defines Americana at a specific cultural moment. Another meaning of abstraction in the photographic realm is the use of non-representational subject matter, creating visual associations and conditions without literal readings.

closure A psychological principle stating that the human eye and mind will translate certain incomplete objects into a whole or recognizable shape. Powerful photographic uses can be applied by making the viewer's mind 'fill in the pieces', creating more engaging and dynamic compositions which activate the mind, as well as the eye.

continuation A law in Gestalt psychology stating that the eye's instinct is to visually follow a simple and orderly path. This inclination can be used to draw the viewer's eye in various directions, or to simply re-emphasize a central subject. An example would be positioning a subject of a portrait in a dynamic setting, allowing leading lines in the surrounding environment to highlight certain features of the sitter.

delay (delayed perception) Considering the amount of visual information a photograph might contain, including powerful compositional, focus and colour elements, a delay can occur as the eye and mind process general or descriptive elements before landing on certain details which fully activate the image. This type of delay can describe the distance between what is physically seen in the photograph versus what the larger narrative or meaning of the photograph might be.

fovea Located in the central macula region of the retina, the fovea is responsible for the perception of central sharp vision. Only 1.5mm wide, the fovea comprises only 1% of the size of the retina, but uses 50% of the visual cortex of the brain. Due to the structure of the human eye, the fovea must be in constant motion, rapidly scanning the area to visually assess a situation.

Gestalt A school of thought developed by German and Austrian psychologists which means 'shape'. A key principle in Gestalt psychology is that the mind understands visual imagery as a whole, rather than as the sum of its parts. Furthermore, visuals are experienced in a regular, patterned and orderly manner. Gestalt ideas can be seen as the opposite of Structuralism and Deconstruction, which focus on unique details and contexts as a philosophical stance.

grouping A central tenet of Gestalt is the human inclination to create visual order through grouping. Such groupings also follow sets of rules, and are organized into six categories, each of which fulfils specific ideals: proximity, similarity, closure, good continuation, common fate and good form.

peripheral vision Vision that exists outside of the centre of the human gaze. The opposite of central or foveal vision, peripheral vision is often employed to detect backgrounds, key details or motion. While the central photoreceptors in the eye are cone cells, which are excellent at determining colour, the edge of the retina are mostly comprised of rod cells. Poor at receiving colour, rod cells are more sensitive to motion and work better than cone cells in low-light situations.

proximity A law in Gestalt thinking that states that the eye will associate visual objects in close proximity as being unified and arranged together. The same number of objects that have different arrangements with regards to proximity will be seen in groups rather than as individual units. This idea has interesting influences regarding the sequence in which certain subjects are seen, as well as providing a measure of organization and sometimes hierarchy within a photograph.

saccades The fast movements of the human eye to visually read a situation. Unlike certain birds, the human eye does not look at a scene in a fixed manner. Instead, the eyes are constantly in motion with quick and synchronized movements, building a complex, three-dimensional mental assessment of a scene from small visual details. In reading another human face, for example, the eyes will move in a series of saccades to assess emotional temperament and distinctive facial features.

semiotics The study of meaning through visual signage and language, a term commonly used in postmodern thinking. Initially developed through linguistics with a distinct focus on verbal and written language, semiotics has expanded to include visual phenomena such as analogy, metaphor and symbolism. One basic tenet of semiotics is the idea that all communication (visual or verbal) is comprised of cultural exchanges of representation, meaning and value. In Martha Rosler's well-known video, *Semiotics of the Kitchen* from 1975, she parodies a cooking show as a feminist critique of a woman's social value in terms of the kitchen.

DENOTATION & CONNOTATION

the 30-second focus

Denotation represents the

literal subject in a photograph, while connotation refers to the inferred or implied subject. The former describes the index in a photograph, and the latter describes how the photograph is read. In Joe Rosenthal's well-known photograph, *Raising the Flag on Iwo Jima*, the denotation would be the soldiers, the flag, the hill and the clouds in the distance. The connotation, however, is the struggle, bravery and heroism of American soldiers overcoming great obstacles in World War II. The famed French theorist Roland Barthes described a slightly different aspect of this duality with his idea of the 'studium', which is the generalized meaning of a photograph, and the 'punctum', which is the subjective aspect in the photograph, and possibly a physical detail, which 'pierces the viewer' on a personal and emotional level. The combination of the literal and inferred is what gives photographs their complexity, and suggests that the true strength of photograph lies beyond its capacity for direct, literal representation. Peter Galassi, former photography curator at the Museum of Modern Art, describes perception in this way: '[ultimately] what we see depends on what we expect to see'.

3-SECOND BIOGRAPHIES
ROLAND BARTHES
1915–80
French Philosopher, author of *Camera Lucida*

JOE ROSENTHAL
1911–2006
Pulitzer Prize-winning war photographer

30-SECOND TEXT
Ben Sloat

Joe Rosenthal, *Raising the Flag on Iwo Jima, 1945*

At the moment of capture, the denotation is set, but the connotation only just begins its life. It extends beyond the photographer's original intentions, depending instead on external factors like context and subjective experience. For instance, this photograph is interpreted by American World War II veterans quite differently than it would be by Japanese World War II veterans.

MEANING

the 30-second focus

The meaning of a photograph

is unavoidably connected to its context. On its own a photograph has little meaning (and none is required), but put against a background such as a museum, a newspaper or a family album, its significance develops. Meaning is also subject to the viewer's personal and cultural biases. A portrait of my mother on my fridge or in a book about the most significant female inventors will have various understandings by each of the viewers. No single understanding of the image is true. The image remains a photograph of a woman, to me significant because she is my mother, to others perhaps sentimental because it will make them think of their mothers and to others because of her cultural and historical significance. Since photography's invention, the debate of its place as a representation of an absolute truth or a work of art has been contested, and within that discourse is the variety of ways one may understand an image. Meaning is created by the one who spends time looking at a photograph, and it is a testament to the investment of the creator of the image to share a message.

3-SECOND FLASH
'A photograph is always invisible; it is not it that we see'.
– Roland Barthes

3-MINUTE EXPOSURE
The Work of Art in the Age of Mechanical Reproduction, a 1936 essay by the German cultural critic Walter Benjamin, is one of the most widely studied texts in art criticism. The essay is directed at modernity's effect on art, and photography as an example of this shift. One of the underlying ideas is that art in modern times has become reproducible, and therefore has lost its original meaning. In this essay, he contemplates how this new technology affects and impacts the viewer's experience.

RELATED TOPICS
See also
CONTEXT
page 124

3-SECOND BIOGRAPHIES
WALTER BENJAMIN
1892–1940
German literary critic and philosopher. Author of the groundbreaking essay *The Work of Art in the Age of Mechanical Reproduction*

SUSAN SONTAG
1933–2004
American author who wrote about photography, culture and media

ALFRED STEIGLITZ
1864–1946
Publisher of *Camera Work*, the quarterly journal that elevated photography to an art form

30-SECOND TEXT
Adiva Koenigsberg

(above) **Ansel Adams,** *Richard Kobayashi, Farmer with Cabbages, California, 1943*

(below) **Dorothea Langue,** *These young evacuees of Japanese ancestry are awaiting their turn for baggage inspection upon arrival at the Assembly Center, California, 1942*

These two photographs both represent the same subject – American citizens of Japanese descent interned at 'War Relocation Camps' during World War II. Above, Ansel Adams was trying to present these citizens as resilient and upstanding. His goal was to ensure their safe reassimilation back into American culture once the war was over. Below, Dorothea Lange presents her subjects with more despair, as she intended to highlight the injustice of the camps themselves. Both of these photographs are 'true', in so far as nothing here is being staged. But the literal truth is of secondary importance to its intended meaning.

HUMAN PERCEPTUAL SYSTEM

the 30-second focus

The most surprising aspect of

our perception is not what we see, but how much our brains deceive us about what we see. Try this: cover your left eye, and keep your right eye on the letter R on the opposite page. Slowly move the book closer to and farther away from your face until the L disappears from your peripheral vision. Notice what remains where the L used to be. Now try it again reversed: cover your right eye, and keep your left eye on the letter L. What is it in your brain that's 'seeing' things that simply aren't there? Our eyes have automatic focus, white balance and exposure. We cannot under- or overexpose. Two images are seamlessly combined into a 180° field of view in our stereo, binocular vision. Hold a finger close to your face and focus on the background to see two fingers – two images not combined by the brain. We do not look; we look around. Our eyes constantly scan in rapid movements called saccades. We assemble a dynamic, continually updated impression – but one that is typically focused primarily on personal safety, emotions and information. Until we really make an effort, most people don't usually notice abstract qualities, colour, tonal and spatial relationships. Photographs quiet that restless attention, and, if we're lucky, teach us to see the world with greater awareness.

3-SECOND FLASH
Human vision is largely automatic (in terms of exposure, focus and white balance), unconscious, dynamic and roaming (vs the static, bounded frame of a photograph).

3-MINUTE EXPOSURE
We see clearly only what we look at directly, in a surprisingly narrow angle of view. Our peripheral vision is tuned into movement – excellent for alerting us to tigers or oncoming cars – but we have to move our eyes and turn our heads to see anything clearly, making subtle exposure adjustments as we do.

RELATED TOPICS
See also
ATTENTION
page 122

EMERGENCE
page 84

FRAME
page 14

SURPRISE
page 120

3-SECOND BIOGRAPHIES
DANIEL SIMONS
1969–
Cognitive scientist who has produced many remarkable studies showing just how flawed human perception is

30-SECOND TEXT
Brian Dilg

The fact that we have a blind spot in each eye is perhaps not surprising, but the fact that our brain refuses to show us our own blindness, and instead shows us things that aren't there, certainly is. At the place on your retina where it connects to the optic nerve, there are no photo receptors. Rather than walk around with two black patches in your vision, your brain dynamically fills in the blind spot with information from the opposite eye. If that eye is covered, then the brain fills in the blind spot with information it can see in the surrounding area – in this case, the brown paper.

SURPRISE

the 30-second focus

3-SECOND FLASH
A photograph can trick the brain into seeing something other than what is depicted, with understanding coming only on second thought.

3-MINUTE EXPOSURE
If you intend to surprise someone with an image, you first have to know that person's visual expectations: the images that they know or at least will recognize. In order to become fluent with such expectations, you need to immerse yourself not only in photography, but also in the visual culture. Painting, cinema, TV – all these visual media play a role in someone's particular visual expectations. The better you know them, the better you can play with them, and the larger your ability to surprise.

We see with our eyes, but

we look with our brain, or the light that enters through our eyes is translated into an understandable image in our brain. That process of translation is highly influenced by our experience: if something looks like a tiger, our brain will send out a warning system, causing the person to get alert and make a run for it. If, however, there was no tiger, but merely a child with yellow and black striped clothes, we are relieved, and the relief shows with a smile. It is that element of surprise where a photograph can be very successful. These photographs lead the brain to make assumptions as to what is depicted in the photograph, but will, upon scrutiny, reveal something else. Well-composed images that keep the viewer's eye long enough inside the frame, and that are able to trick the brain to be surprised are effective images: they keep the viewer's attention, and give him or her a moment of pleasurable viewing. Often-used methods are the recreation of well-known images but changing the key elements in that picture, or recreating the same visual but with different elements.

RELATED TOPICS
See also
CONTEXT
page 124

HUMAN PERCEPTUAL SYSTEM
page 118

3-SECOND BIOGRAPHIES
YAO LU
1967–
Professor at the Central Academy of Fine Arts in Beijing

30-SECOND TEXT
Marc Prüst

Yao Lu, *Ancient Springtime Fey, 2006*

An ancient Chinese painting? A misty landscape? At first, yes; but look closer. The impossibly detailed elements reveal hat this is in fact a meticulously assembled miniature model landscape. Surprise!

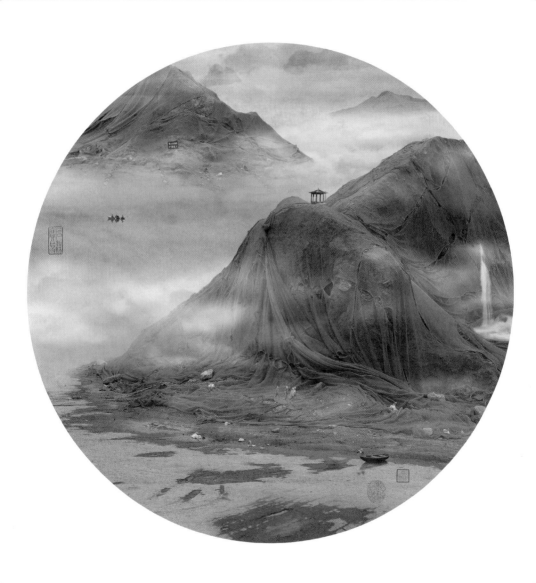

ATTENTION

the 30-second focus

A photograph commands

attention in a variety of ways – through its visual aspects (focus, contrast, colour, composition, size, luminosity), as well as through the isolation and suspension of time, creating a record of a moment that concentrates our often-scattered attention away from linear time. In addition, the photograph records history and preserves an image of a moment. As a result, the viewer's attention is easily transported to historical moments in their own lives or outside of their direct experience. The photograph also isolates attention by providing a visual subject to inspect and to study, allowing details of singular moments to be seen and examined. This aspect can support and verify what has been observed by human vision, creating empirical evidence, but can also create new visuals beyond human vision. Such examples are images of subjects on microscopic or celestial levels, which bring to our attention subjects beyond our direct capacity to observe. One last aspect of photography's ability to affect attention is how the making of a photograph changes behaviour, compelling the photographer to grant greater attention to the world around them in order to determine where to point their camera.

3-SECOND FLASH
The photograph influences attention in a variety of ways, through its visual aspects, as well as through the isolation and suspension of time.

3-MINUTE EXPOSURE
Harold Edgerton considered the ways that the photograph can capture our attention with a moment impossible to see with the human eye. Professor of electrical engineering at MIT, Edgerton is credited for developing the strobe flash into a useful everyday photographic tool. In addition to his lengthy scientific accomplishments, his iconic photographs, such as the *Milk Drop Coronet* and *Bullet through Apple*, offered new visuals that transformed attention given to quick moments.

RELATED TOPICS
See also
HAROLD 'DOC' EDGERTON
page 68

COLOUR OF LIGHT
page 106

3-SECOND BIOGRAPHIES
MICHAEL WESELY
1963–
German fine-art photographer known for his exposures lasting months and even years

30-SECOND TEXT
Ben Sloat

Harold Edgerton, *Bullet through Apple, 1964*

The simple fact that no human eye could ever see this image on its own is enough to command significant attention, even at a glance. The added fact that it has bold, complementary colours doesn't hurt either.

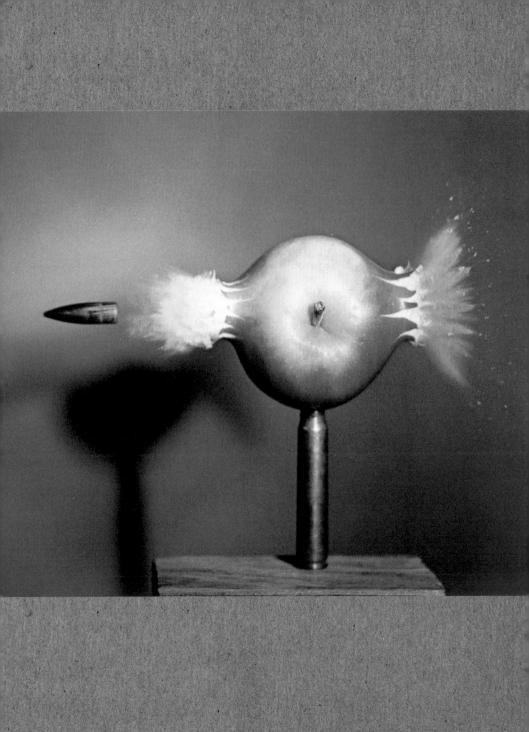

CONTEXT

the 30-second focus

Photography is a medium in

which a fraction of reality is taken out of its original context and presented in an entirely new situation. It is this new context that defines to a large extent how that fraction of reality is then reinterpreted and understood by the viewer. Show the same photograph on a museum wall, in a book or in an Instagram feed and how it is seen and understood will be very different. The space, the images that surround the photograph, the sounds and smells that exist all define the way the photograph is read and interpreted. All the elements that surround the photograph influence the mood, perception and experience of the viewer. Even if pictures are said to say more than a thousand words, most pictures need a context to be properly understood: the text on the advertising poster to explain that this toothpaste makes your breath smell fresh, the museum wall itself to understand that we are looking at art. Those pictures, too, often have a caption or some explanatory text. You could even say that a photograph itself is too small a part of reality, and it is the context, the accompanying text, the place where it is shown or the other pictures that go with it that place it back into a larger reality.

3-SECOND FLASH
A photograph can never be seen outside of its context: how and where you see the picture inevitably influences how you will read and understand the contents of the photograph.

3-MINUTE EXPOSURE
For some pictures, the context of the situation is clearer or easier to understand than for others. A family dinner with a Christmas tree in the background raises fewer questions than an image from a conflict zone, where it is often hard to understand who the 'bad guy' is. In these cases, it is clear that text can help to clarify the context, but even with the family dinner, what if the caption reveals a family secret? You will read the picture in a new way. Context defines the picture.

RELATED TOPICS
See also
DOCUMENTARY &
PHOTOJOURNALISM
page 38

FRAME
page 14

NARRATIVE
page 44

3-SECOND BIOGRAPHIES
TRENT PARKE
1971–
Australian photojournalist who often creates humour or unexpected emotions by photographing situations outside of their usual context

30-SECOND TEXT
Marc Prüst

NASA Curiosity Mars Rover
Bright 'Evening Star' Seen from Mars is Earth, 2014

Rip a photo out of its Martian context, and it becomes utterly mundane. Add a single word of explanatory text, and suddenly the image is infused with significance.

MIRRORING

the 30-second focus

Typically there are three forms

of theoretical mirroring that can come from photographs. Mirroring can be seen as a representation of the time the photograph was taken. The chosen materials used to create the photograph are a reflection of the era in which the photograph was taken. Is it a digital photograph, colour film, large format? Physical and factual elements – all of these defining characteristics are obvious reflections of a specific time in history. Secondarily, photography always inherently mirrors the state of mind of the photographer. Composition and content can speak to and reveal the evolution and maturation of the photographer. The photograph can tackle a modern concept as a mirror of society. Finally, once the photograph is viewed, mirroring comes from the viewer. The viewer projects a narrative onto the photograph, with or without knowing the description of the image. They see in the image what they are thinking, both consciously and unconsciously. Their own circumstances become part of the photograph, and of the photographer's intentions, completing a cycle of mirroring.

3-SECOND FLASH
Regardless of the initial purpose of every photograph, an image mirrors the time in which it was taken, the photographer and the viewers themselves, all combining to create the final narrative.

3-MINUTE EXPOSURE
The mirror has long been used as a metaphor for art's purpose (Hamlet says the role of art is 'to hold, as 'twere, the mirror up to nature, to show virtue her own feature, scorn her own image, and the very age and body of the time his form and pressure'), and photography is uniquely positioned to capitalize on that perspective – as a literal mirror to a physical event, and a figurative mirror to the viewer's subjective experience.

RELATED TOPICS
See also
DENOTATION & CONNOTATION
page 114

PORTRAITURE
page 46

REPRESENTATION
page 20

3-SECOND BIOGRAPHIES
GORDON PARKS
1912–2006
An African-American photographer well known for emotional narrative images in both documentary and fashion photography

30-SECOND TEXT
Jackie Neale

Gordon Parks, *Ingrid Bergman at Stromboli, Italy, 1949*

The cycle continues into the composition itself – gesture mirrors gesture, a subject reflects its background and tension fills the space between.

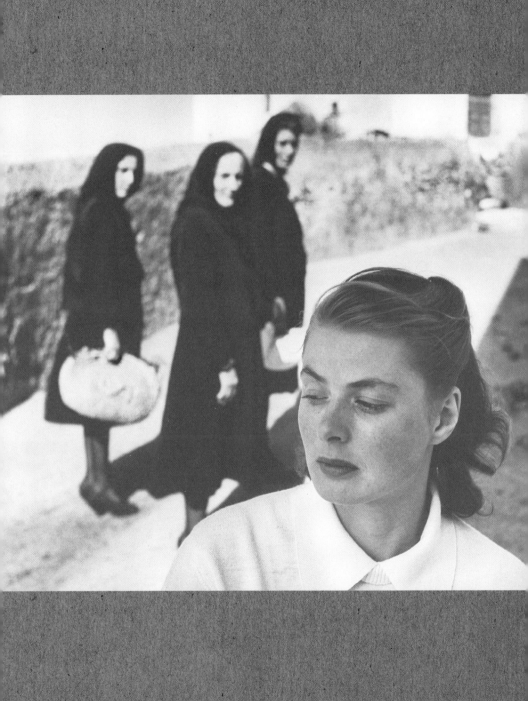

REPRODUCTION/ DISTRIBUTION

the 30-second focus

When we speak about

photographs, we cannot speak about originals, not in the same sense as we can speak of an original painting, even if the first photographs, for example the daguerreotypes, were unique irreproducible pieces. In this sense, photography, though a visual art, has more resemblance to the art of literature. A first edition of a book can then be compared to a vintage print – fairly rare but not unique (a vintage print being a photograph printed by or under the direct supervision of the photographer). A negative in the earlier days of photography, and a digital file nowadays is merely the starting point for a picture, and depending on how it is printed, the resulting photograph will look different. Once that print is done, it can be reproduced indefinitely, and also, in theory, distributed endlessly. With digital photography, reproduction and distribution have only become easier and cheaper. Whereas during the Vietnam War, for example, a photographer had to first develop a role of film and then transfer it with an early version of a scanner/telex combination, nowadays anyone with a smartphone is able to take a picture anywhere, and share those images instantly with a worldwide audience.

3-SECOND FLASH
Almost every photograph can be reproduced. This is unique to photography, as each additional picture is as much the original as the first picture.

3-MINUTE EXPOSURE
As the art market is helped by scarcity, photographers (and gallery owners) often limit the number of reproductions of their prints: they call them limited editions, number and sign them and hope that their pieces might be seen as more unique, and more valuable. But it is in fact only when a photographer has passed away that vintage prints get a truly unique quality, because until that point, it is only a matter of trust between the photographer and the collector.

RELATED TOPICS
See also
DIGITAL CAMERA
page 64

EARLY PHOTOGRAPHY
page 34

3-SECOND BIOGRAPHIES
MIKE KRIEGER
1986–

& KEVIN SYSTROM
1983–

Co-inventors of Instagram, one of the most popular online photo-sharing services, with over 400 million users who have uploaded well over 40 billion images

30-SECOND TEXT
Marc Prüst

The AP Leafax revolutionized photojournalism by giving users the ability to digitally transmit their images from the field directly to a national photo desk. While portable, it was heavy, transmission times were slow and there were 18 steps required per photo upload. Of course, the race goes on, and today, professional photojournalists must compete with citizen journalists for the scoop.

5 November, 1926
Born in Hackney,
London, England.

1944–46
Serves in the British
Army

1946
Enrols in the Chelsea
School of Art and the
Central School of Art
in London

late 1940s
Works as a painter

1948–55
Teaches drawing and
becomes an art critic
publishing many pieces
in the *New Statesman*

1958
Publishes his first novel
A Painter of Our Time

1962
Self-imposed exile to
France from Britain

1972
BBC broadcasts *Ways
of Seeing* and publishes
its companion text

1972
His novel *G* wins
the Booker Prize and
The James Tait Black
Memorial Prize

1975
Moves to a farm in
Quincy, France after
publishing *A Seventh
Man: Migrant Workers
in Europe*

1980
Shortlisted for
Booker prize

1991
Wins the Petrarca-Preis

2008
From A to X is
shortlisted for the
Booker Prize

2009
Wins the Golden
Pen Award

2011
Wins the Groeneveld
Foundation Award

2013
Receives the Lucie
Award for Outstanding
Achievement in Fine Art,
and screens *The Rain
House*, a feature film
he wrote and directed

2 January, 2017
Dies at age 90, in
Antony, France

JOHN BERGER

John Peter Berger was born in

London, England, on 5 November, 1926. He was an art critic, novelist, painter and poet. His work dealt with his fascination with art and the experience of people living under oppression. Berger's Marxist humanist ideals and strong opinions about art have made him a controversial figure.

He began his career as a painter. From 1948–55 he taught drawing, and at the time also became an art critic, publishing many reviews and essays in the *New Statesman*. In 1958 he published his first novel, *A Painter of Our Time*. In 1962, Berger exiled himself to France because of his growing distaste for life in Britain.

In 1972, the BBC broadcast his four part television series *Ways of Seeing* and its accompanying text of the same name, which has revolutionized the way that fine art is understood and read. The first part of the series builds upon Walter Benjamin's essay *Art in the Age of Mechanical Reproduction*, which explains how modern technology and the ability to mass reproduce art, especially photography, has changed the meaning and cultural significance of art. Berger elaborates on Benjamin's critique, deconstructing the process of representation. In the second instalment, he shows how the nude in western art has systematically objectified women, similarly to the tradition of the nude in photography. In the final two chapters he connects consumer society's relationship to ownership and art.

In 1975, Berger's research for his book *A Seventh Man* led to an interest in the world left behind by migrant workers. With his frequent collaborator, photographer Jean Mohr, they sought to document the intimate lives of these farmers. This work led him to settle in Quincy, a small village in Haute Savoie, where he lived and farmed up until his death in Antony, France, in 2017.

Berger was a great supporter of collaborations, and throughout his career has done so with various writers and thinkers such as Mike Dibb, who directed *Ways of Seeing*, the Swiss director Alain Tanner, the theatre director Simon Burney and the artists Juan Munoz, among others.

He has published several novels, studies of single artists and sociological studies, and won the Booker prize for his novel *G* in 1972, and several awards since then. He donated half of the money from the Booker prize to the Black Panther party in Britain. His recent essays have dealt with photography, art, politics and memory, and he has written short stories that appear in *The New Yorker*.

IMAGE PROCESSING & REPRODUCTION

anti-aliasing A technique used to mask the straight, staircase edges of square pixels most evident when a digital image attempts to represent curves or diagonal edges. These 'jaggies' are masked by inserting pixels using transition colours between the neighbouring colours on either side of the edge.

burn Darkening areas of a print while protecting the rest of the print from receiving additional light. Burning is typically used to darken overexposed areas and highlight detail that would otherwise be lost during the primary print exposure period. Digital imaging software provides the equivalent capability using tonal-adjustment and masking tools.

channel In digital images, a channel is one component of an image: a single colour, hue, saturation, luminosity or transparency. Digital cameras capture three channels: red, green and blue.

cinemagraph An electronic digital image in which a small portion of the frame is moving slightly in an endless loop while the rest of the image remains static, creating a sense of motion or time. The term was coined by photographers Kevin Burg and Jamie Beck. Created by combining multiple images or video frames together.

colour profile Known as an ICC (International Color Consortium) profile, it describes how a physical device captures or reproduces mathematically specified colours, complete with the eccentricities of the device. This includes input devices that create images (cameras, scanners etc.) and output devices that reproduce images (monitors, printers etc.). By communicating the characteristics of each device, ICC profiles help maintain consistent colour throughout an imaging workflow.

colour space A device-independent colour space is an abstract mathematical model of a finite range of colours, such as AdobeRGB, sRGB and ProPhotoRGB. A device-dependent colour space describes how a specific physical device (camera, scanner, printer/paper/ink, monitor) captures or reproduces colours from specific numbers (RGB or CMYK values).

compositing Combining multiple images together using masking (revealing selected areas of each image) and/or transparency. Modern digital imaging software uses a multi-layer model, where each image layer can have a mask as well as many degrees of overall transparency. Photorealistic compositing relies on matching lighting, vantage point, focal length, focus, palette and precise edge masking.

contrast The range of tones in an image from darkest to lightest. A high-contrast image has a wider range of tones than a low-contrast image. Raising contrast with digital imaging tools pushes mid-tones apart, toward black and white; lowering contrast does the opposite.

dodge Preventing selective areas of a print from receiving light (and thus getting darker) while the rest of the print is created. Photochemical prints are made by exposing light-sensitive paper to an image that has been focused onto the paper by passing light through a negative. Dodging is typically used to prevent areas from getting too dark and losing shadow detail. Digital imaging software provides equivalent capability using tonal adjustment and masking tools.

edition(ing) A curatorial practice designed to preserve the highest possible value for reproductions by placing strict limits on the number of copies made of any given image. The smaller the edition, the fewer prints, and the higher the price tends to be. The practice of editioning is essentially a contract between an artist and collectors whereby the artist promises not to issue additional prints after the sale of an image in order to protect the value of each print.

histogram A graph showing the number of pixels in a digital image from darkest to lightest. A luminosity histogram reflects tonality; single-channel histograms indicate the number of pixels of a given colour at each tone from darkest to lightest.

hue The wavelength of light, the visible product being 'which' colour is seen: red, blue, green, for example. Colour is described in terms of hue and saturation.

luminance Luminance and luminosity are terms commonly used to describe brightness.

scanning The digitization process, whereby an image of the analogue world is converted to a finite number of square pixels, each with a specific colour. A scanner is essentially a digital camera that moves relatively slowly across and down a scene to record an image one line at a time.

signal-to-noise ratio The presence of a wanted signal (for example, an accurate image of a scene) relative to unwanted noise (such as misfiring pixels generated by a hot sensor). Particularly problematic as a digital image sensor approaches black and the signal level becomes zero, closest to the level of spurious electronic noise.

MANIPULATION

the 30-second focus

Manipulation of an image

technically can be anything from a slight exposure change to the compositing of several images into one. Image manipulation is used to perfect a photographer's vision. Working with cloning and blending tools, skilled photographers can seamlessly remove and add parts of images. Using multiple layers, photographs can be combined with whole new elements from other images to composite a photo illustration. Non-destructive changes can be made to sharpness, focus, colour balance, contrast and more with adjustment layers. Layers and adjustment layers can all be applied to specific areas with the refined control of 'masks'. Images can be cropped, rotated, skewed, warped and expanded. Filters can be applied to add or remove texture and grain from a digital image. Depending on how realistic a photographer wants an image to be, heavy manipulation can create endless derivations. However, the ethics of photojournalism enforces strict non-manipulation guidelines. Minimal exposure and colour changes are permitted. Beyond that, the image is not considered a factual depiction. Manipulate your photographs to your heart's content or keep it minimal; the control is completely in your hands once you master image retouching.

3-SECOND FLASH
While cameras have limitations in high-contrast situations, photographers are also able to manipulate the tonal range to create impressions that would otherwise be invisible.

3-MINUTE EXPOSURE
Manipulating a photo ranges from simple modifications in colour and exposure, to moving whole elements around, in order to duplicate them or modify the image from its original form. An example of this is to take a bird from one photograph and put it into another photograph's sky.

RELATED TOPICS
See also
TONAL ADJUSTMENTS
page 142

COLOUR CORRECTION
page 140

3-SECOND BIOGRAPHIES
DAVID LACHAPELLE
1963–

An American commercial photographer working in photo illustration and fantastical imagery using compositing and manipulation

30-SECOND TEXT
Jackie Neale

Brian Dilg, *Adam*

Viewers don't usually see before-and-after comparisons. Seen together like this, clearly the lower image is a manipulation of the one above. But on its own, the manipulated image is perfectly believable, while also being much more visually engaging.

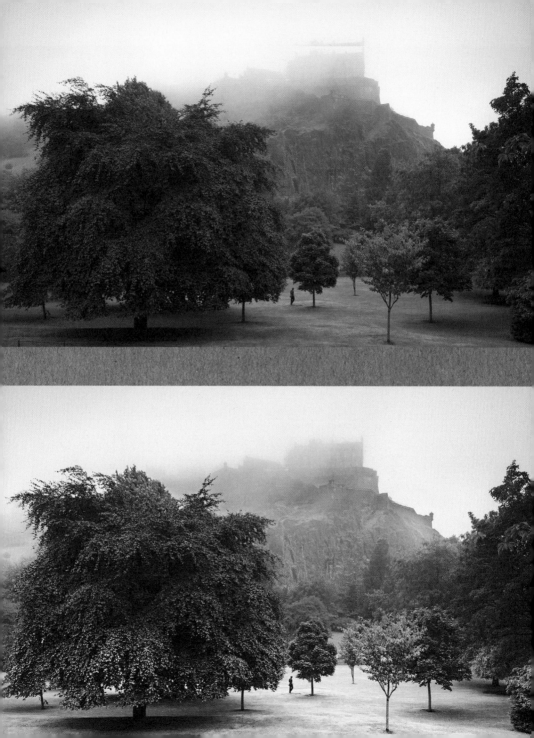

NOISE & GRAIN

the 30-second focus

Film grain is the visible crystal

grain structure of film, or how much texture a film has. During film processing, variations in chemicals, temperature and times can increase or decrease grain. Higher-speed films will demonstrate more grain because the particles which capture the image are larger; the converse is true with lower-speed films. Under- and overexposure of film will lead to more grain. Reproduction size (the degree of enlargement) of an image shot on film will also affect how noticeable grain is. Noise is the digital equivalent of grain. Noise is created by a digital sensor from sources other than the image in front of the lens (known as the 'signal'). There are two type of noise: chrominance, which is inaccurate colours, and luminance noise, which is inaccurate brightness. Noise increases with heat (a problem during long shutter speeds and at higher-ISO settings), and as sensor size decreases. Film grain varies in size and shape, so, unlike digital noise, it does not represent the limit of resolution. For digital cameras, darker regions will contain more noise than the brighter regions; with film, the inverse is true with respect to grain.

RELATED TOPICS

See also
FORMAT
page 66

FILM CAMERA
page 56

DIGITAL CAMERA
page 64

3-SECOND FLASH
Noise and grain are random variations of tone or colour in a developed negative or a digital image.

3-MINUTE EXPOSURE
Chrominance noise is usually undesirable. Luminance noise resembles film grain and, although it affects an image's sharpness, it can be a desirable aesthetic. Grain has been a part of people's visual memory since film's invention, and is often associated with documentary footage (typically shot on higher ISO film that has more grain). In the digital era, luminance noise can be used to create nostalgic or emotional images, especially if images are converted into black and white to simulate documentary-style film or textured fine-art images.

3-SECOND BIOGRAPHIES
DIANE ARBUS
1923–71
Portrait photographer known for her grainy images of offbeat subjects in her early career

30-SECOND TEXT
Adiva Koenigsberg

Frank Gallaugher, *Burning of the Clocks, 2011*

Not every shot has to be studio-quality – viewers will accept imperfections like noise as long as the subject and action are sufficiently engaging.

COLOUR CORRECTION

the 30-second focus

RELATED TOPICS

See also
COLOUR RENDITION
page 60

COLOUR OF LIGHT
page 106

HUMAN PERCEPTUAL SYSTEM
page 118

Colour correction is arguably

the most challenging process after taking the photograph. A photograph has to be colour corrected to 'normal'. What did the colour really look like when the photograph was made? Before taking photographs in specific lighting conditions, it is recommended to take an initial capture with a MacBeth colour chart (or greyscale chart). Keeping this photograph for colour reference provides ease in the Raw-processing workflow by enabling all images within those lighting conditions to be colour corrected quickly, making black, middle grey and white settings based on the reference chart. This base setting would be what photographers consider their 'normal'. It is from this starting point that images can then be adjusted creatively within the colour palette of the image. Photographers often change colour balance, accentuate colours and amplify them to express their personal vision and mood. Achieving this is greatly facilitated by working within a 'closed loop' system, using a colour-calibrated monitor, scanner and printer (or other output type). Calibration ensures that colour accuracy is maintained, despite the specific limitations or eccentricities of each device in the workflow.

3-SECOND FLASH
Colour correction is imperative in photography. Digital cameras have made it easy to photograph in light sources with multiple colour temperatures, and then colour correct in post-production.

3-MINUTE EXPOSURE
All digital cameras have a white-balance control, which, if set correctly, will render correct colours based on the lighting in which a photograph is taken (although Raw files have no permanent commitment to any white-balance setting). If there are multiple colour temperatures, it is best to set white balance to automatic, let the camera average the colours, and then colour correct in Raw conversion.

3-SECOND BIOGRAPHIES
TREY RATCLIFF
1971–
A commercial photographer famous for embellishing the colour of his images for dramatic effect. His photographs consist of highly saturated colours often depicting cityscapes and wide-open landscapes. Many of his photographs are hyperrealistic, and though very vibrant and very sharp, are typically based on and playing off of the idea of 'normal'

30-SECOND TEXT
Jackie Neale

Brian Dilg, *Peter*

The eye is extremely sensitive to human skin tones, and will recognize if they are not colour corrected.

TONAL ADJUSTMENTS

the 30-second focus

Lightening and darkening

selective areas of a photograph is common practice. In the darkroom, this is called 'dodging' (lightening) and 'burning' (darkening). Digital darkroom software provides tools to select precise areas ('masking'), adjust their tone and colour, and to experiment with endless changes without degrading the image. If rooted in real-world experience, skilfully modified images will actually feel more 'real' than unmodified images. Ansel Adams was a master printer whose images were extremely manipulated, but the tonal relationships were so expertly orchestrated that they seemed to capture the drama of nature with naturalistic authenticity. Photographers also make extreme changes to create images that simply don't exist outside of the photograph. A viewer does not normally compare versions of an image, and will accept surprisingly radical interpretations. To experience the neurological imperative for making local adjustments, stand indoors and look at someone at a window on a bright day. They will appear largely silhouetted. Make a tunnel with your hand and look only at them. Their features will become more clear as your eyes adjust. This is an amplified version of the subtle adjustments made by your eyes as they rapidly move through a scene.

RELATED TOPICS
See also
HUMAN PERCEPTUAL SYSTEM
page 118

DAYLIGHT
page 100

HIGHLIGHTS & SHADOWS
page 94

3-SECOND FLASH
Photography mimics the way our eyes assemble an image from multiple glances by lightening and darkening areas of a photograph after initial capture.

3-MINUTE EXPOSURE
The reasons that a 'manipulated' image often feels more natural than an untouched image are based on the fact that we assemble a complex impression as our eyes move rapidly through a scene, dynamically adjusting our tonal perception. A camera typically captures only a single exposure, so these selective adjustments happen after the image is captured, or by combining multiple exposures into a single image ('HDR' or High Dynamic Range imaging being one technique).

30-SECOND TEXT
Brian Dilg

Brian Dilg, *Dew on Branches, Norway*

Sensor technology has matured to the point where even heavy manipulations can be carried out in post-production without sacrificing significant image quality. Highlights can be pulled back, shadows pushed up, noise reduced, blemishes cloned out, distortion corrected – all resulting in an image accepted by the viewer as real.

MASKING

the 30-second focus

Masking is a technique of

blending multiple images and effects together by controlling the visibility of pixels on each effect layer or image layer. Masks are one of the most powerful tools within the image- manipulation repertoire. There are several types of masks within Adobe's dominant Photoshop software. Typically, a selection is made first by drawing a closed outline around each area to be revealed. This selection can be modified directly, or made temporarily visible and modified with paint tools using 'Quick Mask' mode. Selections are then typically applied as layer masks, which hide the selected pixels of an image layer (for example, another photograph) or the effect on colour or tone made by an adjustment layer. Called 'alpha channels', masks do not simply hide or show pixels on each layer. They provide eight binary bits (256 degrees) of visibility from opaque to invisible using a greyscale to represent transparency. Vector masks, also used to control visibility of layer areas, are precise, resolution-independent, mathematically described geometric shapes built around spline curves (points with straight or curved points extending from either side of them). Precise masks are the digital-collage technique behind otherwise impossible images created by seamlessly compositing multiple photographs together.

3-SECOND FLASH
Masking in photographic post-production gives incredible flexibility to seamlessly composite multiple images and effects into a final image.

3-MINUTE EXPOSURE
Masks are most useful when compositing and retouching photographs, and when adjustments need to be isolated to very specific parts of image layer stacks. The sharpness of mask edges must match the optical focus of the original image in that area in order to form a realistic composite.

RELATED TOPICS
See also
MANIPULATION
page 136

3-SECOND BIOGRAPHIES
MICHEL TCHEREVKOFF
1954–
One of the first photographers to utilize digital techniques in photography, mastering image manipulation with software that predated the invention of Photoshop

30-SECOND TEXT
Jackie Neale

Brian Dilg, *Curtains*

Here you can see a deconstructed composite image, in which the various elements have been 'sewn together' by masking.

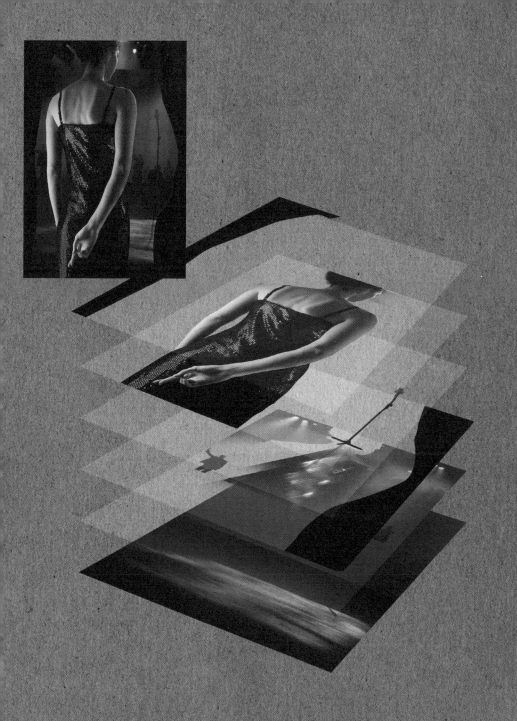

RAW CONVERSION
the 30-second focus

3-SECOND FLASH
Raws provide flexibility and quality, but the files are large. A secondary image must be extracted by applying settings; Raws are not viewed directly.

3-MINUTE EXPOSURE
Every camera manufacturer has their own proprietary Raw format, tied closely to the way their sensors capture light. Adobe has also developed an open standard for a universal, non-proprietary Raw format called DNG – digital negative – to which some photographers convert their original Raws.

Since digital cameras feature

instantaneous images, the idea of 'processing' a digital 'negative' may comes as a surprise. However, to exploit the full capability of digital capture requires the use of the Raw file format. A Raw file is not exactly an image. It cannot be viewed directly as such on any monitor. It could be more accurately thought of as a description of possibilities for an image. To become viewable, decisions must be made about the 'look', and a copy extracted to another file. Most cameras produce a JPEG, which sacrifices quality for portability. It is precisely because it has no inherent or permanent commitment to fundamental aspects of an image including contrast, saturation and white balance that Raw provides such unparalleled flexibility compared to film. Raw processing software such as Photoshop, Capture One, Lightroom, Aperture and others use proprietary algorithms to allow an enormous range of adjustments to a Raw file, including exposure, white balance, contrast, saturation, sharpening, detail enhancement, noise reduction and more. Adjustments can be global as well as local (i.e. applied only to selected areas of an image). The original Raw itself remains forever unchanged, although infinite variations can be readily produced from it.

RELATED TOPICS
See also
DIGITAL CAMERA
page 64

TONAL ADJUSTMENTS
page 142

COLOUR CORRECTION
page 140

30-SECOND TEXT
Brian Dilg

Camera manufacturers typically include proprietary Raw-conversion software with the purchase of a Raw-capable camera, but this software is almost invariably slower and less refined than the programmes available from industry bigwigs like Adobe, Apple and PhaseOne.

There's a logic to the arrangement of the basic Raw conversion controls, starting with White Balance, then moving through tonal adjustments and finally on to saturation settings.

Following the tonal settings, the Raw-conversion tools get progressively more advanced – you can manipulate the hue, saturation and luminance values of each individual colour channel, you can add some split toning (tinting your highlights one colour and your shadows another), and even make selective brush adjustments to local areas of the image.

SHARPENING

the 30-second focus

Digital 'sharpening' cannot

change how a lens was optically focused or how sharply it was engineered. Rather, it's a software technique that, used properly, can create the illusion of a sharper image. It does so by introducing an artefact that mimics a higher level of sharpness where it's most needed: along edges. The technique is to increase contrast where the software believes it has found reasonably high-contrast edges. The user selects how many pixels on either side of an edge will be brightened on the bright side, and darkened on the dark side (typically 1–3). This imitates the way a sharper or higher-resolution image would render a more sudden transition between a dark tone and a light tone. Although completely artificial, this technique can be very effective at enhancing the appearance of sharpness. If used without restraint, the illusion of sharpness will fall apart, and those edge halos will draw attention to themselves for what they are: digital artefacts. If used without limiting the effect to edges alone (called 'masking'), even subtle differences in tone will be exaggerated in areas that will not benefit from it, like blue skies, effectively adding noise to the image.

3-SECOND FLASH
Digital sharpening creates the illusion of sharper edges through edge contrast. It does not actually make an image more sharply focused.

3-MINUTE EXPOSURE
Digital sharpening controls have three components: amount (strength of the contrast increase), radius (how many pixels on either side of an edge will be affected) and threshold (what gets sharpened). Unfortunately, the default threshold in most software is zero, meaning contrast is increased everywhere, effectively adding noise. Look for a feature (often a keyboard modifier) that allows you to make the sharpening mask visible, and adjust the threshold so only high-contrast edges are affected.

RELATED TOPICS
See also
NOISE & GRAIN
page 138

30-SECOND TEXT
BRIAN DILG

Brian Dilg, *Fjord, Norway*

The magnified detail on the left (coming from the bottom-left section of the landscape above) shows a reasonable amount of sharpening applied. You can see there's a miniscule halo along the edge of the roof, but when viewed from a proper distance, that will simply appear that the edge is even sharper. The detail on the right, however, has too much sharpening applied, and it has induced artefacts in the water that appear as noise.

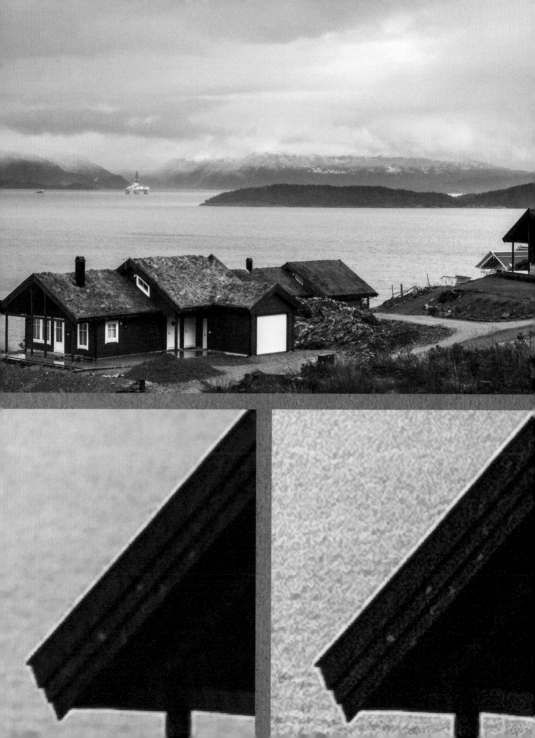

1969
Born in Dresden

1989
Leaves her native East Germany just before the fall of the Berlin Wall; moves to Munich

1990–96
Studies painting at the Akademie der Bildenden Künste in Munich, Germany

1999
Works I completed

2000
Changes her name to Loretta Lux

2000
First exhibition

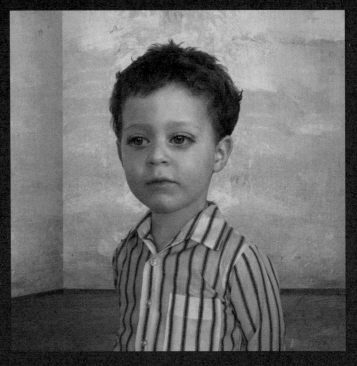

Study of a Boy 3, 2002

2001
Works II completed

2002
Bayerische Kunstförderpreis

2002–03
Works III

2004
Works IV

2004–07
Works V

2005
Wins the Infinity Award for art photography from the International Center of Photography (ICP) in New York

2005
First monograph with Aperture Foundation, New York

2006
First major retrospective exhibition at the FotoMuseum Den Haag, in The Hague, Holland

2006
Second solo show at Yossi Milo Gallery

2007–10
Works VI

2009
Solo exhibition at the Kulturhuset Museum in Stockholm, Sweden

LORETTA LUX

If there is one thing that defines Loretta Lux, it is control. She decides every minute detail in her images and leaves nothing to chance. Instead of relying on the decisive moment, her images are constructed over an extended period, from two months to a whole year. Her production therefore is not larger than some six pieces a year. But she not only controls her photos, her own image reflects that love of control as well: Loretta Lux is not her real name, but a pseudonym adopted before her first exhibition in 2000. Her real name has since been a closely guarded secret.

Lux was born in East Germany, and from an early age she realized that being under the control of the (communist) state went against her personality. She has said that not being able to study art as a child is one of her biggest disappointments. Right before the fall of the Berlin wall in 1989, she moved to Munich to study painting at the Art Academy. She soon found out that painting was not her preferred medium, it being too 'messy'. She prefers the controlled environment of a computer.

The idea of painting, of being in complete control of the result, however, very much appealed to Lux, and she started to apply this principle of painting to her photographic work, which began in 1999. She portrays children, and the pictures are not to be seen as reflections of their personalities, but 'a metaphor for the idea of childhood'. She first photographs children, often the kids of friends, and dresses them in a pre-selected wardrobe reminiscent of the 1970s. Except for the hair, she does all the styling herself. These images are then transported into new backgrounds, either from her personal photographic archive or her own paintings. From there she manipulates the entire image: the skin becomes even and perfect, the eyes are slightly too large for their heads, the limbs just a bit too long. The result is a portrait not of a child but of childhood. And as soon as the work is out there, the artists lets go; there is no more control on how the image will be read. In her own words: 'I want people to decide what to see'. She wants control over her work, not over her audience.

APPENDICES

RESOURCES

BOOKS

The number of worthy books on photography is vast and worth a lifetime of reading. This is just a tiny taste of great books.

Believing Is Seeing
Errol Morris
(Penguin Books, 2014)
The documentary film-maker and indefatigable investigator adds a fresh piece of essential inquiry into the ways in which photographs can hide more than they show, while purporting to do just the opposite.

Camera Lucida
Roland Barthes
(Vintage Classics, 1993)
A slim but essential volume in the canon of photographic theory.

How To Read A Photograph
Ian Jeffries
(Thames & Hudson, 2009)
Although not as directly instructive as promised by the title, this is nevertheless packed with examples of concise readings of works by many important practitioners.

The Ongoing Moment
Geoff Dyer
(Canongate Books, 2012)
If you have no appetite for theory or an exhaustive survey of history, or if you are merely looking for a great book, there is no better

written adventure than Geoff Dyer's masterful and completely accessible masterpiece, tracing subjects as motifs across disparate master photographers.

The Photograph
Graham Clarke
(Oxford University Press, 1997)
An excellent investigation into major subject areas throughout the history of photography as well as a thorough introduction to the surprising complexities of decoding photographic meaning.

The Photograph As Contemporary Art
Charlotte Cotton
(Thames & Hudson; 3rd edition, 2014)
An excellent introduction to what constitutes fine art, concept-driven photos.

The Photographer's Eye
John Szarkowski
(The Museum of Modern Art, 2007)
Another brief book packed with useful ways of looking at and constructing photography.

Photography Changes Everything
Marvin Heiferman
(Aperture 2012)
A startling examination of how photography has radically changed our very behaviour and culture.

MAGAZINES

A note of caution: an overwhelming number of magazines focus on showy techniques and driving lust for the latest gear. While it's good to be informed about technical matters, keep an eye out for thoughtful analysis and articles.

Aperture
aperture.org/magazine
A respected art magazine published by the non-profit Aperture Foundation.

Black & White
bandwmag.com
Devoted to the art of B&W photography.

Blind Spot
BlindSpot.com
A triennual art journal that devotes most of its space to fine art images.

Burn
BurnMagazine.com
Focusing on the work of emerging photographers, curated by *National Geographic* legend David Alan Harvey.

Daylight
DaylightBooks.org
Devoted to contemporary documentary photography accompanied by essays by the photographers.

WEBSITES & BLOGS

dpreview.com
One of the most thorough sites for reviews worth consulting when you're shopping for equipment.

lens.blogs.nytimes.com
Outstanding documentary and photojournalism photos, multimedia, video, essays and interviews curated by the editors of *The New York Times*.

PetaPixel.com
Mostly tech- and equipment-related news, with a particular affection for images created by technically intricate means.

Photo-eye.com
Photo Eye is a photography gallery in Santa Fe, New Mexico, but it's also an impeccable reference for great images via its bookstore, blog, its curated lists of fine art and documentary photographers and more.

strobist.blogspot.com
An eminently instructive blog focused on lighting techniques using strobes.

NOTES ON CONTRIBUTORS

EDITOR

Brian Dilg is a film-maker, artist, writer and educator. He has served as the founding chair of the photography department of New York Film Academy since 2010, where he also teaches film-making workshops. He has served as a spokesperson for Canon for whom he wrote and acted in a series of photography tutorials. He is a Photoshop Adobe Certified Expert, and worked as a commercial retoucher for clients including Polo Ralph Lauren, Victoria's Secret and NBC.

He grew up under the tutelage of his father and grandfather, both avid photographers. In addition to commercial assignments, his work has been exhibited and collected worldwide, and published in *The New York Times*, *Time Out*, the *Village Voice*, on book covers for *Simon and Schuster*, *Hyperion*, *Doubleday* and others. His cinematography work also has been the recipient of numerous honours.

He has served as director, writer, editor, cinematographer, composer and actor on over 90 films since 1995. He is the founder and CEO of *The Curious Otters*, a media-production company based in New York City. His website is www.briandilg.com.

CONTRIBUTORS

Adiva Koenigsberg was born in New York City. She is a photographer and cinematographer who specializes in analogue photographic media. An adjunct instructor at the International Center of Photography and The New York Film Academy, her work focuses on portraiture and personal stories. Her website is www.thenthis.org.

Jackie Neale is a NYC-based fine-art and editorial photographer. She is visually inspired through interpersonal relationships and the barrier that disappears/appears once a camera is introduced to the mix. Exhibitions of her photographs have been mounted in galleries and museums throughout the United States. Jackie has also appeared on NPR/WNYC, in the documentary *Time Zero: The Last Year of Polaroid*, has been published in worldwide and throughout the US, in print and online for the Metropolitan Museum of Art and has recently successfully raised funds to self publish her first monograph *#SubwaySeries*. A complete list of events, projects, exhibitions, awards and clients can be found at www.jackiephoto.com.

Marc Prüst is a photography consultant, curator and teacher. He edits books, creates exhibitions, teaches and organizes workshops and masterclasses, lectures and writes on photography and advises photographers how to develop and market their work. He is currently the Artistic Director of the Photoreporter Festival in Saint Brieuc, France. In 2010, in cooperation with the Noorderlicht Gallery and Festival, Marc launched the Northern Lights Masterclass, a one-year masterclass for professional photojournalists and social-documentary photographers. He was one of three curators for the FotoGrafia festival in Rome from 2010–12, and the creative director of the only photo festival in Nigeria, LagosPhoto. From 2001–7, Marc organized and installed exhibitions around the world for the World Press Photo Foundation. In 2005, he was responsible for the exhibition and award-winning publication *Things As They Are, Photo Journalism in Context since 1955*. In 2007 he moved on to Agence VU, and in 2009 he left the agency to start as a freelance curator, consultant and teacher. His website is www.marcprust.com.

Ben Sloat is an artist, professor and writer, having earned degrees from UC Berkeley and the SMFA. His recent solo exhibitions include those at Steven Zevitas Gallery, Boston (2010, 2013); Coop Gallery, Nashville (2013); Galerie Laroche/Joncas, Montreal (2011); MMX, Berlin (2010); Gallery 126, Galway (2010); Front Gallery, Oakland (2009) and ACC Gallery in Taipei (2009). Recent group exhibitions include those at the MFA, Boston; Dublin City Gallery/The Hugh Lane, Dublin; Peabody Essex Museum, Salem, Massachusetts; Northwest Museum, Spokane, Washington and Queens Museum, New York. He has written essays for *Exposure* and *Aperture Magazine* and was a 2009 Faculty Fulbright Scholar to Taiwan. His website is www.bensloat.com.

INDEX

ACKNOWLEDGEMENTS

The publisher would like to thank the following for permission to reproduce copyrighted material:

2, 7, 9, 15: Brian Dilg; 17: © Robert Capa © International Center of Photography via Magnum; 19: © Henri Cartier-Bresson/Magnum Photos; 21: © Corbis; 23: Brian Dilg; 25: Digital image courtesy of the Getty's Open Content Program; 27: © Elliott Erwitt/Magnum Photos; 28: Chris Felver/Getty Images; 35: Apic/Getty Images; 37: Frank Gallaugher; 39: PA Images/AP Photo/Eddie Adams; 41: Brian Dilg; 43: Library of Congress, Washington DC; 45: W. Eugene Smith/Time & Life Pictures/Getty Images; 47: Digital image courtesy of the Getty's Open Content Program; 48: © Christie's Images/The Bridgeman Art Library © Courtesy: Sprüth Magers Berlin London/DACS 2014; 59: Brian Dilg; 63: © Christie's Images/Corbis © 2010 MIT. Courtesy of MIT Museum; 68: Henry Groskinsky/Time & Life Pictures/Getty Images; 75: Brian Dilg; 77: Erik Kessels/In Almost Every Picture #9/KesselsKramer Publishing; 79: Kirsanov Yury; 81: Margaret Bourke-White/Time & Life Pictures/Getty Images; 83: Brian Dilg; 85: © Lorrie McClanahan; 87: © Haris Panagiotakopoulos; 88: © Arno Rafael Minkkinen, Courtesy Edwynn Houk Gallery, New York; 95: © Trent Parke/Magnum Photos; 99: Weegee (Arthur Fellig)/International Center of Photography/Getty Images; 101, 103, 105: Brian Dilg; 108: Courtesy the artist and David Zwirner, New York/London; 115: PA Images/AP Photo/Joe Rosenthal; 117T: Library of Congress, Washington DC; 117B: National Archives and Records Administration; 121: © Yao Lu; 123: Cincinnati Art Museum, Ohio, USA © courtesy of Palm Press, Inc./The Bridgeman Art Library, © 2010 MIT. Courtesy of MIT Museum; 125: NASA/JPL-Caltech/MSSS/TAMU; 127: Gordon Parks/Time & Life Pictures/Getty Images; 129: Morio; 130: Ulf Andersen/Getty Images; 137: Brian Dilg; 139: Frank Gallaugher; 141, 143, 145, 149: Brian Dilg; 150: Digital Image Museum Associates/LACMA/Art Resource NY/Scala, Florence.

All reasonable efforts have been made to trace the copyright holders and to obtain permission for the use of copyright material. The publisher apologizes for any errors or omissions in the list above and will gratefully incorporate any corrections in future reprints if notified.